SECRET
CHELTENHAM

David Elder

AMBERLEY

For Clare and David

First published 2019

Amberley Publishing
The Hill, Stroud
Gloucestershire, GL5 4EP

www.amberley-books.com

Copyright © David Elder, 2019

The right of David Elder to be identified as the
Author of this work has been asserted in accordance
with the Copyrights, Designs and Patents Act 1988.

ISBN 978 1 4456 7332 5 (print)
ISBN 978 1 4456 7333 2 (ebook)

British Library Cataloguing in Publication Data.
A catalogue record for this book is available from the
British Library.

Origination by Amberley Publishing.
Printed in Great Britain.

Contents

Introduction

The story of Cheltenham – around 200 years ago just a small market town with one main street which, following the discovery of its mineral waters in 1716 and the subsequent visit by George III in 1788, rose to become England's most complete Regency town – has often been told. From the 1830s onwards, when the fashion for taking the waters started to decline, Cheltenham reinvented itself as an important centre for religion and education, and eventually as a place of festivals, music, sport, tourism and leisure. However, its history dates back much further than the beginning of the nineteenth century. Traces of Iron Age settlements are still visible on Cleeve Hill to the north-east and Leckhampton Hill to its south. Moreover, a Neolithic long barrow (4000–2000 BC) was reputedly excavated in the town in 1832. Nevertheless, it was not until AD 773 that the first reference to Cheltenham was recorded when it was known as 'Celtan hom', possibly deriving from 'well-watered valley [hamm] of (the hill called) Cilta or Celta'. This rich and diverse background has led to a wealth of interesting source material, from which Cheltenham's fascinating history can be told, retold or re-evaluated.

In this book I have looked again at some of its history, concentrating on the previously unknown or lesser-known aspects. Tangible evidence is revealed, for instance, of the town's medieval past through the remnants of old ridge and furrow ploughing or the survival of witch marks in Leckhampton. Cheltenham's lucrative, though clandestine and short-lived, cultivation of tobacco during the seventeenth century is also recalled through highlighting a hidden location in Charlton Kings, once known as Tobacco Close. Focusing particularly on topics such as secret and unusual places, local characters, and remarkable events and associations, I have also intertwined these with themes covering law and order, war, rights and social reform, and aspects of the town's 'hidden' history. While Cheltenham's image may still be commonly perceived as white middle-class, that view ignores the fact that travelling ayahs from India and former slaves from West Indian plantations trod its streets during the early nineteenth century, revising the perception that Cheltenham only became a multicultural town from the 1960s. Appreciation of the town's fine Regency architecture also gains a new perspective once the context of the town's links with slavery-derived wealth is understood.

Finally, through delving into many previously untold stories, a portrait of a town is revealed that has displayed an unusually high degree of innovation, creativity and ingenuity. Where else, for example, would you find the inventor of public-key cryptography, working in close proximity to an art teacher who, during the Second World War, used his skills to camouflage airfields and other critical assets? Where, too, would you find the park that witnessed the first descent of an Englishman by parachute or the place where the world's first steam-powered bus service was launched? Part of Cheltenham's appeal is that it constantly surprises visitors or residents alike with remarkable and unexpected links and associations. I hope that *Secret Cheltenham* has contributed to the recording of the town's lesser-known history.

1. Secret Places

Apart from being home to the Government Communications Headquarters (GCHQ), one of the world's most secretive locations, Cheltenham has many more secret places, some of which lie 'beneath the surface', are 'hidden', or are no longer in their original positions and, therefore, may be considered 'out of place'.

Beneath the Surface

One of the interesting, though lesser-known, features of Cleeve Hill is that it contains several natural caves formed by landslip. The most significant of these, discovered by 1910, is known today as Isaac's Cave. Located on the southern part of Cleeve Cloud South Quarry, in 1957 the cave was the scene of a dramatic rescue when a caver became trapped around 34 metres inside. After summoning help from the police, fire brigade, and even a party of miners from Cinderford, the man was eventually freed after thirteen hours by the Mendip Rescue Organisation. Following this incident, its entrance has now been partially sealed off with a large boulder.

Cleeve Cave interior. (*Cheltenham Chronicle and Gloucestershire Graphic*, 26 February 1910)

Although Cheltenham has few surviving examples from its medieval past, the remnants of old ridge and furrow ploughing are still visible in several parts of the town, especially Leckhampton. First recorded in the Domesday Book (1086) as 'Lechametone' and 'Lechantone', meaning 'homestead where garlic or leeks were grown', Leckhampton originally supplied vegetables for the royal manor of Cheltenham. Medieval Leckhampton was farmed using the open-field system, in which large fields owned by the lord of the manor were farmed in strips leased by individual tenants. The ridge and furrow pattern that we still see today was formed by teams of oxen – the standard unit in medieval England being eight, in four yokes – pulling the plough. Over the years, as the soil became increasingly ridged in the centre of the strips, parallel ridges formed approximately two-thirds of a metre high at their centre. The width of the strips varied depending on the contours of the ground and the possibilities of turning around the oxen, but typically are around 7 metres in these parts. Reverse S-shaped patterns can also be seen where the furrows were slightly twisted to the left as the oxen were turned at each headland. Today, this pattern can just be seen reflected in several of Cheltenham's streets, including St Paul's Lane, Lypiatt Street and Tivoli Street.

In Leckhampton, good examples of medieval ridge and furrow are in evidence close to the old village centre, near Leckhampton Court, today a Sue Ryder Care hospice. They are even visible from the modern suburban developments bordering areas such as Collum End Rise, close to the path signposted to Leckhampton Hill. The hidden patterns are best revealed in snow or low winter light, accentuating the height of the ridges through casting long shadows into the furrows. Years ago, fields like this would have been widespread on the slopes and at the top of Leckhampton Hill. Today, it is only the fields, which have

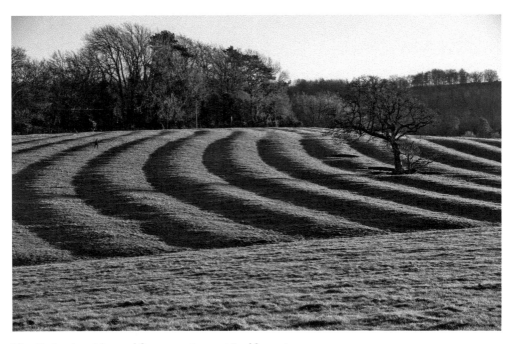

The distinctive ridge and furrow patterns at Leckhampton.

escaped the effects of quarrying, modern farming methods and natural erosion, that still survive here. They were probably converted to pasture at the beginning of the nineteenth century to meet the growing population's demand for increased dairy produce.

Leckhampton also provides tangible evidence of the ancient fear of witches. While fairly common during the Middle Ages, the fear of malevolent spirits became more widespread in the seventeenth century following publication of James VI and I's treatise entitled *Daemonologie* (1597), in which he set out his belief in magic and witchcraft. This led some house owners to follow the practice of making apotropaic marks at vulnerable parts of the house. Deriving from the Greek word *apotrepein*, meaning 'to ward off', apotropaic marks consist of symbols or patterns carved into the fabric of the building to keep witches away. Those entry points in the house considered at greatest risk included doors, windows and fireplaces.

Many medieval and Stuart buildings, including Shakespeare's Birthplace in Stratford-upon-Avon and the Tower of London, have examples of apotropaic marks. Although very few of Cheltenham's pre-Georgian buildings survive, at least one containing apotropaic marks still exists locally. This may be found in Leckhampton Court, one of Gloucestershire's oldest surviving medieval houses. Built by Sir John Giffard, whose effigy lies in nearby St Peter's Church, the earliest part of Leckhampton Court's current building dates from around 1330. Apotropaic marks have been discovered in several rooms there, dating from the Tudor period. Typically, the marks are Christian and include two intertwined letters 'V' said to signify *Virgo Virginum*, 'Virgin of Virgins', to invoke the protection of the Virgin Mary.

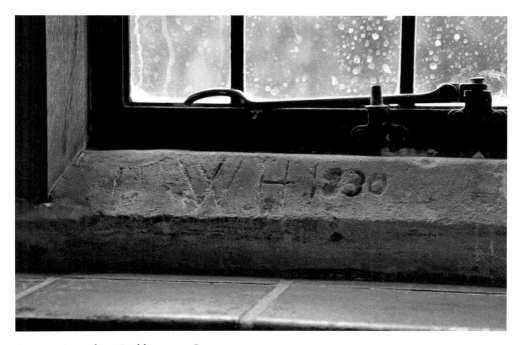

Apotropaic marks at Leckhampton Court.

Another secret that lies hidden 'beneath the surface' is the fact that during the seventeenth century Gloucestershire was celebrated as one of best areas in the country for growing tobacco. A song from *The Marrow of Compliment* (1654) even contained a marginal reference to 'ye praises of Cheltenham tobacco'. First brought to England in 1565, tobacco was introduced into the Cheltenham area *c.* 1619, possibly encouraged by Richard Pate, the founder of Cheltenham Grammar School, who corresponded with Sir Humphrey Gilbert, the half-brother of Sir Walter Raleigh. Early records show that 12 acres of land at Arle Court were used to cultivate tobacco. It was also grown on the banks of the River Chelt and at Postlip. It was a short-lived venture, however, since in December that year James I, under pressure to protect the interests of colonial planters in Virginia and Maryland, declared it illegal. Regardless, tobacco cultivation continued in Cheltenham for the following seventy years, its popularity arising through providing employment opportunities for poor labourers. In 1652 an Act was passed expressly prohibiting the planting of tobacco in England. Initially, the Cheltenham growers obtained a concession to keep the crop planted for the first year only, and then also for the following year. However, in 1658 concerted action was taken to destroy the Cheltenham plantations when a thirty-six-horse troop led by John Beaman was sent from Gloucester. Nevertheless, the troop was met by uncooperative local magistrates and an armed crowd intent on defending the fields. Beaman returned to Gloucester, reporting that it would take ten men four days to destroy the crop. Such was the town's continuing reliance on tobacco that the Scottish cartographer John Ogilby, who produced Britain's first road atlas, wrote in 1675 that Cheltenham's inhabitants were 'much given to plant tobacco, though they are supprest by authority'. However, by 1689 following mass production of the cheaper Virginia tobacco, Cheltenham's trade became less profitable and then production died out almost completely. The last recorded mention of the illicit trade was made in 1691 when a Cheltenham miller, Richard Teale, requested compensation from the government for destroying a small field of tobacco he had planted 'in ignorance of the law'.

While it is hard to visualise tobacco growing in the town's green spaces today, perhaps the best place to imagine this is in an area of Charlton Kings once known as Tobacco Close. Located on the west side of the footbridge over the River Chelt at the bottom of Brookway Lane, and subsequently divided when the Cirencester Road was cut in 1826, this 'close of meadow or pasture' was mentioned in sales records dating both from 1725 and 1743.

One of the town's least known underground sites is the barrel-vaulted crypt beneath Holy Trinity Church in Portland Street. Opened in 1823, Holy Trinity was the first new church to be built in Cheltenham since medieval times. It was also the first church in the town to operate on the proprietary system whereby the use of pews was bought on a shareholding basis. Designed by G. A. Underwood in the Gothic style, the church seated 1,350 people. The crypt was built of brick and contains approximately 400 burials contained in stone coffins. Arranged in multiple layers in four rows, the burials, which filled the crypt to capacity well before 1900, provide fascinating insights into the town's history during much of the nineteenth century.

While the town's Anglo-Indian connections are particularly well represented there, also of interest are the military personnel who retired to Cheltenham. Summers Higgins, for

The site of Tobacco Close, now a modern housing development.

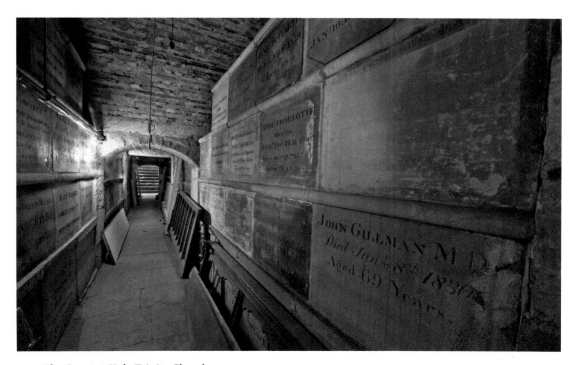

The Crypt at Holy Trinity Church.

example, who was buried in the crypt in 1843, after retiring to live at No. 1 Berkeley Place on half-pay, was a medical surgeon and inspector general of military hospitals who rose to become the chief medical officer of Jamaica. He served in the Peninsular War (1809–11), being present at the Battle of Talavera (1809), and after Waterloo (1815) he looked after the wounded at Brussels. At Talavera he was taken prisoner by the French, but was released by Napoleon for the care he provided to the French wounded. Napoleon provided him with a passport to travel to Paris and supported his return to England.

Another underground secret is Hewletts Reservoir, at the top of Harp Hill. Following expansion of the town and its suburbs during the early part of the nineteenth century, together with increasing demand for clean water, the Hewletts 5-acre site was chosen by the Cheltenham Water Works Company to allow water to be collected from springs near Northfield Farm. Given its relatively high altitude the site enabled water to be transferred along 2 miles of cast-iron pipes to the town by gravity, rather than by pumping. The first reservoir, which could hold nearly 2 million litres, was built of stone in 1824. Designed by the distinguished Scottish civil engineer James Walker, for much of its working life it was used to store local spring water. As this was prized for its purity, it led to the reservoir becoming the preferred source of supply for the local brewing industry. As demand increased, two additional reservoirs were constructed in 1839 and 1847. A fourth was added ten years later but was abandoned in 1965, and then demolished in the 1990s. During the 1960s the reservoirs were modernised with concrete columns and roofs.

Today, the reservoirs collectively store 45 million litres of clean water extracted from the Severn and then, following treatment at the Mythe Water Works, pumped for 10 miles from Tewkesbury. Contributing approximately half of the town's water needs, the

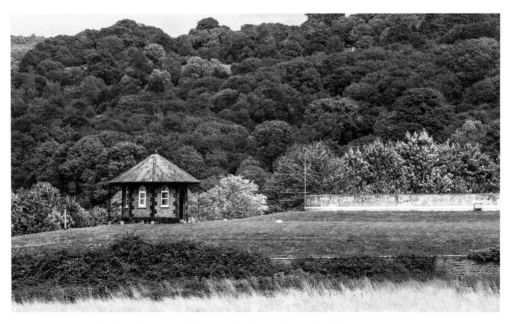

Hewletts Reservoir showing its pavilion, probably a *c.* 1870 valve house.

Hewletts Reservoir has also helped to provide healthier living conditions for the local inhabitants over the years. The supply of Severn water from the Hewletts, for example, helped to reduce the number of typhoid outbreaks in the town from the end of the nineteenth century. Before then, reliance on local wells, heavily polluted by nearby sewers and drains, caused a significant risk to public health.

Lastly, perhaps the town's most secret underground place lies at the corner of Clarence Road and Prestbury Road, adjacent to the entrance gates to Pittville Park. Here lies a 10-foot square underground chamber dating from the late nineteenth century. The chamber was rediscovered in 2012 during a project to restore the gates. Initially, its purpose was unclear, with theories including its possible use as an electricity sub-station, a transformer chamber, or even a place for storing hay to supply horse-drawn carriages. Recent research now indicates that, since it did not contain switchgear, it probably operated as a transformer chamber rather than a sub-station. It served supplied electricity to the neighbourhood both for public lighting and domestic purposes.

Although private electrical installations began in Cheltenham as early as 1882 at the Winter Garden in Imperial Square, a public supply for the town was not introduced until 1894 when a central electricity station was built in Arle Road. The first electric street lamps in Cheltenham became operational in 1897. As demand increased, a series of sub-stations and transformer chambers was built around the town to lower the 2,000-volt supply to 110, as required for domestic levels. The largest sub-station above ground was opened in 1895 in Manchester Street (now Clarence Street).

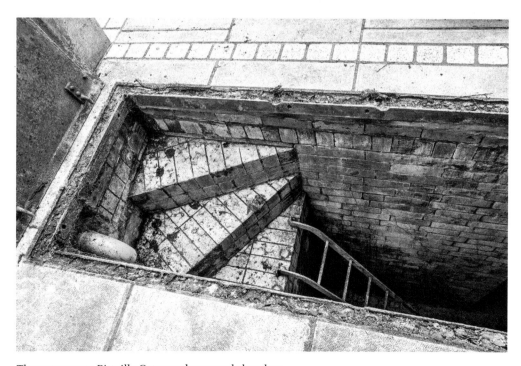

The entrance to Pittville Gates underground chamber.

Cable cross-section, also present on 'dragon and onion' lamp stands.

The underground transformer chamber at Pittville Gates appears to be the largest in Cheltenham. A similar structure in the High Street is narrower by 3 feet. While the latter is lined in concrete, the Pittville chamber was built with good quality engineering bricks (produced by J. C. Edwards of Ruabon, Wales). It is thought that the chamber was operational in 1897 and supplied the electricity to a new 30-volt arc lamp, fitted to the centre of the overthrow in Pittville Gates as part of the celebrations to mark Queen Victoria's Diamond Jubilee. Another interesting detail is the fact that the cross-section of the cables (still visible in the chamber) is represented on the town's famous 'dragon and onion' street lamps.

DID YOU KNOW?
During the Second World War, Winston Churchill held secret discussions with George Dowty in a bunker in the grounds of Arle Court. Now known as the Manor by the Lake, Arle Court was acquired as the headquarters for Dowty's undercarriage design business in 1935. By the end of the Second World War the company had produced approximately 87,000 undercarriages for RAF aircraft, including Lancasters and Hurricanes, and around a million hydraulic units.

Hidden

One sort of secret place that is contained within two of Cheltenham's historic buildings is an observatory. Still present on the skylines of both the Ladies' College and Thirlestaine Hall, the observatories served the pursuits of education and amateur astronomy respectively. The first to be built was in 1897 when the copper-coloured dome, measuring 60 feet in circumference, was added to the college's 65 foot-high tower bordering Montpellier Street. The driving force behind its construction was Dorothea Beale, the pioneering educational reformer. Beale attended lectures on astronomy at an early age, which ignited her passion for mathematics and related subjects. Appointed as college principal in 1858, she quickly ensured that astronomy was included as part of the curriculum, the subject initially being taught by visiting male lecturers. The observatory's opening coincided with the completion of the Princess Hall and was marked by a visit to the college by Empress Frederick, daughter of Queen Victoria and mother of Wilhelm II. The local press included the following description: 'A staircase leads up the tower, through the clock room, to the observatory, which is prepared to accommodate a telescope and other astronomical apparatus; the revolving dome, pierced by a shutter, is constructed of steel covered with papier mache and canvas painted sea green.'

During the Second World War, the dome was used as an observation post, but later fell into disuse. Partial restoration was completed in 1962, when the dome's covering was replaced with nylon fabric painted with waterproof vinyl resin, and further work carried out in 1991. The college now plans to refurbish the old fittings previously used to house a

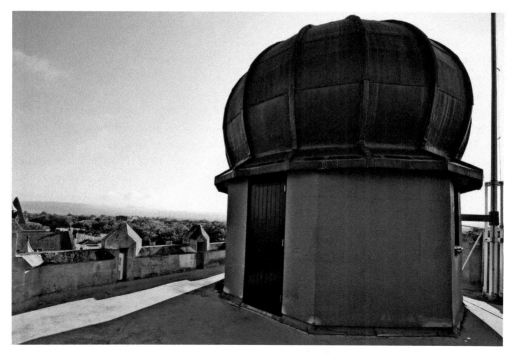

The observatory at Cheltenham Ladies' College.

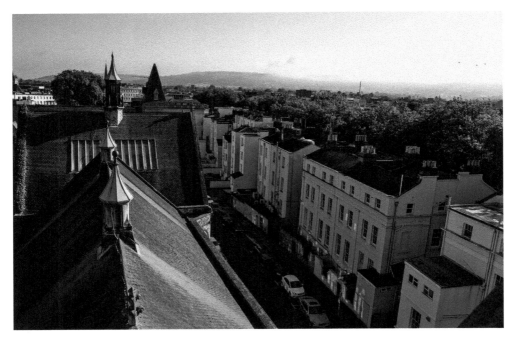

A view from the top of the college's 65-foot-high tower.

telescope and repair the opening mechanism of the domed roof so that it can once again rotate to provide the most favourable view across the night sky. Equipment has already been purchased, including astro-binoculars and a specialist camera that can photograph distant objects in deep space. This will enable students to conduct the astronomical observations once enjoyed by their predecessors.

The town's other observatory was commissioned *c*. 1909 by the industrialist and amateur astronomer John Player as a practical and attractive addition to the tower of his home at Thirlestaine Hall (now converted into apartments), Thirlestaine Road, which was originally built in 1855–57. In 1916, disaster nearly struck when a serious fire causing damage estimated at over £60,000 swept through the house, almost totally surrounding the dome. Remarkably, it was the observatory that saved the situation. By chance, Player was in his observatory when he discovered early on that the roof was on fire. Furthermore, it was only through the dome that the firemen were able to gain access to the roof to extinguish the flames. Fortunately, the dome was left undamaged, along with Player's valuable astronomical instruments. Player was known locally as a generous benefactor who enjoyed sharing his passion for astronomy with other amateurs. Among these was Dr Reginald Lawson Waterfield, whose father became Headmaster at Cheltenham College. At the age of sixteen, Waterfield gained an international reputation as an astronomer, in due course becoming vice president of the Royal Astronomical Society and president of the British Astronomical Association. On 2 May 1920 Player and Waterfield used the 6-inch telescope at Thirlestaine Hall to witness the total eclipse of the moon, recording the event by taking 2-inch-diameter-sized photographs through the telescope using 60-times

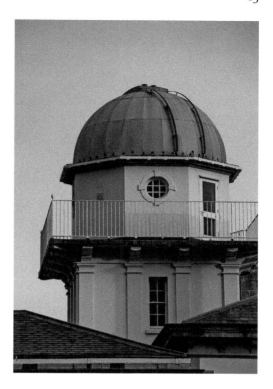

The observatory at Thirlestaine Hall.

magnification. Four years later, they also gained remarkable views of Mars, this time using a fine garden sieve placed over the object glass of the telescope to reduce dazzle and enhance the finer detail of the image!

A different type of hidden landmark is located on Leckhampton Hill. While the limestone quarrying activity that took place there, particularly from 1800 to 1920, forms a well-known part of the town's industrial heritage, lesser known is the ill-fated scheme, begun in 1922, to produce lime on the hill and transport it to Charlton Kings by a specially built standard-gauge railway. Today, the concrete foundations of four large steel limekilns are the main visible reminders of this project, which only lasted five years. The scheme was funded by a government loan to ease unemployment after the First World War. Construction of the limekilns, manufactured by the Middlesbrough firm of Priest, and 2 kilometres of railway track was completed by September 1924. Standing 23.5 metres high it was hoped that, once the kilns had been fired up using producer gas made from coal, they could make 300 tons per day. However, this level was never attained and the resulting lime was not of sufficiently good quality to make the enterprise worthwhile. The standard-gauge railway, connecting the kilns to a depot at Southfield Farm in Charlton Kings and thence to join the railway line at Charlton Kings, employed a three-rail system with a halfway passing point below an overbridge that once spanned Daisybank Road. Today, one of the most popular paths from the Daisybank Road car park follows the line of the railway, which, at its steepest section, was designed to cope with a 1 in 6 gradient. In the end, although an impressive engineering feat, it produced little of real benefit.

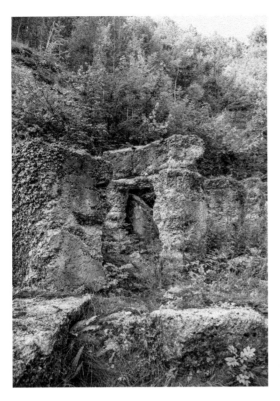

The remains of the limekilns, Leckhampton Hill.

Another hidden building, this time located in Greenway Lane to the south-west of Leckhampton Hill, is on the site of the former Ullenwood army camp (now private property). This is a well-preserved secret nuclear bunker dating from the Cold War era. Built in the 1950s with concrete walls approximately 2 feet thick, the bunker was one of nineteen that would provide the country's emergency government if tensions escalated between the USSR and the West during the Cold War. The building, which covers almost 1,300 square metres, was built on two storeys, centred on an operations room to coordinate anti-aircraft defences. Hermetically sealed to protect against radiation poisoning, it could accommodate 200 people within a self-sufficient environment for long periods, and was intended to house the South West regional seat of government in the event of nuclear attack. Power was supplied through a large Russell-Newbery generator. Communications facilities included thirty-six phone lines and radio coverage for Gloucestershire and six neighbouring counties. During the 1960s or 1970s it is thought that the Labour Prime Minister Harold Wilson visited the bunker as part of contingency planning test arrangements. By the end of the 1950s the building had become the headquarters for the Gloucestershire Civil Defence Corps, while in 1963, only one year after the Cuban Missile Crisis, it was sold by the War Office to Gloucestershire County Council for use as an emergency centre. Under the council's ownership it was used as a training centre for the police, fire and emergency services, as well as a storehouse for goods seized by the local Trading Standards office.

The secret nuclear bunker at Ullenwood.

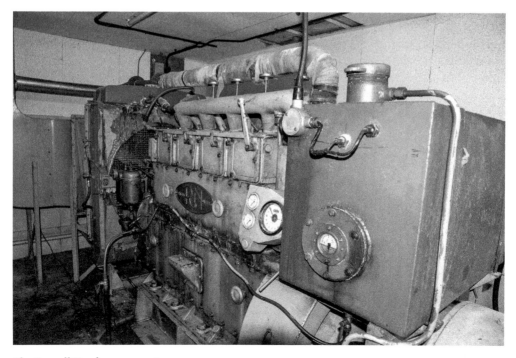

The Russell-Newbery generator.

Cheltenham is celebrated as the home of Government Communications Headquarters (GCHQ), one of the three UK intelligence and security agencies, which works alongside the Security Service (MI5) and the Secret Intelligence Service (MI6) and whose functions were first avowed on 12 May 1983. While its main building, known as the Doughnut (on account of its circular design with central courtyard), is visible through the perimeter barbed wire fence bordering Hubble Road and Telstar Way, details of the secret operations carried out from inside are rarely given. The scale of the building, which houses the largest computer suite outside the USA, is best appreciated from the air. Its roof comprises over 11,000 square metres of aluminium and is based on the design of Wimbledon's Centre Court roof, while its central courtyard is big enough to accommodate the Royal Albert Hall.

GCHQ's association with Cheltenham began in 1950 when staff were transferred from Eastcote under a government relocation scheme. News that it was a Foreign Office department and not a 'less desirable' branch of the Civil Service was greeted with a sigh of relief by the town's deputy mayor. Initially, GCHQ set up a small set of offices in Clarence Street to manage the move from Eastcote. Thereafter, it occupied two sites, at Benhall Farm and Oakley, sites used by the US Army during the war. A rumour developed during the 1950s that a 3-mile tunnel connected the two sites. Approaching the needs of the twenty-first century, however, a new building was needed, particularly to foster a more collaborative working environment. Its new building at Benhall was completed in 2003 and opened by the Queen on 24 March 2004.

While a veil of secrecy routinely shrouds most of GCHQ's work, one of its remarkable successes is celebrated publicly in the town. An Institute of Electrical and Electronic Engineers' plaque at The Wilson museum gives proud acknowledgement to GCHQ's invention of public-key cryptography, which today, as reflected in the use of 'https' websites, is fundamental to the secure running of the internet. By as early as 1975, GCHQ's James Ellis had proved that symmetric secret-key systems, involving the prior distribution

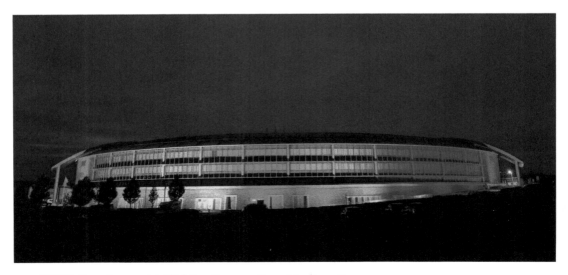

GCHQ, lit up in 2015, highlighting its commitment to diversity.

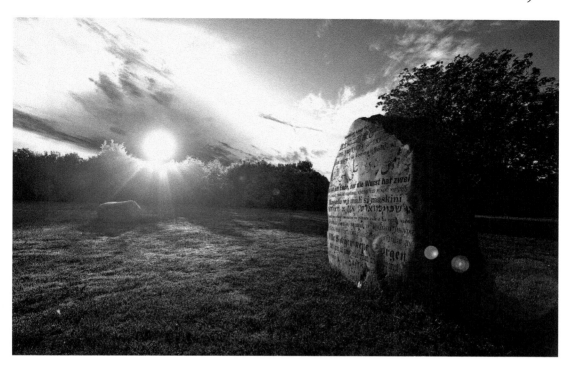

Above: The Listening Stones in Hester's Way Park.

Right: The 'Spy Booth' artwork by Banksy.

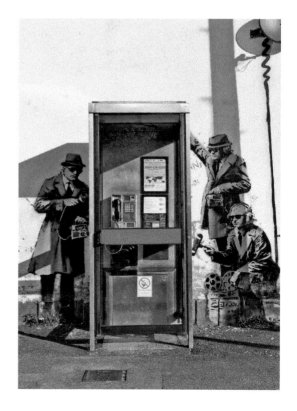

of a secret key to all correspondents, were not the only solution. This significant insight was then further developed by his colleague Clifford Cocks, who, with the help of Malcolm Williamson, showed how public-key cryptography could work in practice.

Other sites in the town associated with GCHQ's work include the *Listening Stones* sculpture created by Gordon Young in 2004 in Hester's Way Park. Located next to the Doughnut, this sculpture, dubbed 'Cheltenham's Stonehenge', comprises nine glacial granite boulders engraved with encrypted codes and cyphers, mysterious symbols, messages and puzzles inspired by the work of GCHQ and created in collaboration with children from Monkscroft Primary School, sixth-formers from Cleeve School, GCHQ staff, local residents and journalists. Another reminder of GCHQ's presence was produced by Banksy, the famous street artist. Dubbed the 'Spy Booth', the artwork, which depicts three men using listening devices to eavesdrop on a telephone box, appeared on a private house in Hewlett Road overnight on 13 April 2014. Although the artwork was vandalised at the original site and lost, a copy has been reproduced at the entrance to Grosvenor Terrace, just off the High Street.

Out of Place

Located more than halfway along Crippetts Lane on the edge of Leckhampton are some gate piers, surmounted by pigeons, believed to have been used at the entrance to the Old (or Original) Well. It was on this site (now located within the Ladies' College) that the story of Cheltenham Spa began. In 1716, a farmer noticed pigeons pecking at salt

Gate piers from the entrance to Old Well, now on Crippetts Lane.

deposits round a spring, an indication that the water had mineral qualities. William Mason, a prosperous hosier, acquired the site and caused a well to be built, and word of the waters' healthy properties began to spread. However, it was not systematically developed until the well was taken in hand by Mason's son-in-law, Henry Skillicorne, in 1738. The saline and mildly chalybeate waters were recommended by doctors as a cure for virtually everything, particularly for leg ulcers, bowel complaints and 'female diseases'. Its fortunes peaked during George III's five-week visit in 1788, when it was renamed the Royal (or King's) Well. However, by the time the Ladies' College took over the site for development in 1873 the fashion for taking the waters had declined. The well now lies buried beneath the college's Princess Hall. It seems likely that when the college was built the gate piers were transferred to the Crippetts Lane site. Today, they are classed as a Grade II listed structure, and pigeons still feature on the borough coat of arms.

Another unusual feature within the town that may be classed as 'out of place' is found at Dean Close School. In 1986, as part of its centenary, a new cloister adjacent to the school chapel was filled with specially mounted glass from St John the Evangelist Church, Aston Magna, north of Moreton-in-Marsh. In 1979 the church became redundant. The diocese of Gloucester then granted permission for the windows to be transferred to Dean Close Chapel. Depicting the Last Supper, St John as Apostle and Evangelist, and the Passion, Resurrection and Ascension of Jesus, the beautifully displayed panels provide a tangible reminder of the school's motto: *Verbum Dei Lucerna* (meaning 'God's word, a guiding light'). The windows date from 1873 and 1885 and were produced by the firm of Heaton, Butler and Bayne.

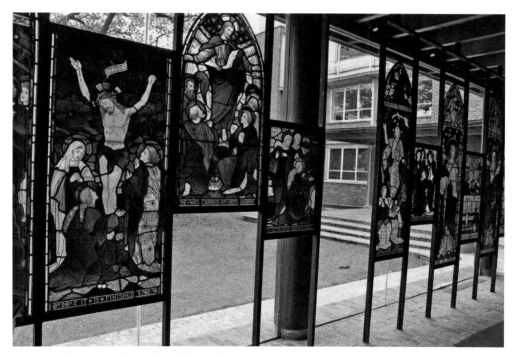

Glass panels at Dean Close Chapel, formerly at Aston Magna.

2. Local Characters

Over the years, Cheltenham has been associated with many figures of national and international importance. However, there have also been noteworthy local characters whose stories deserve attention. These have made their mark in a wide range of endeavours, from chimney sweeps to pianists, and pedlars to pumpers, to name but a few.

The Town Crier

Dating back to medieval times, and even before, town criers were the recognised way of making public proclamations on any subject before the advent of general literacy. Today, while many towns and cities still have criers, either on a paid or voluntary basis, their duties have become ceremonial in nature, focused mainly on contributing to special occasions, and local and charity events.

The first recorded mention of a crier in Cheltenham, an office that then was usually combined with that of catchpole (constable), was made in 1416–17. Two early incumbents

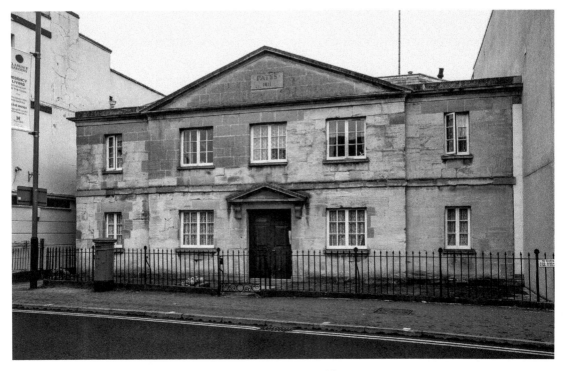

The Almshouse, where Nanny the Bellwoman resided in old age.

of the position were Nicholas Baker, who served between 1417 and 1441, and John Baker, described as 'catchpol and proclamator', who fulfilled the duties in the late 1440s. Later on, Cheltenham's historian John Goding recorded that the role was once filled by 'an eccentric female' called Nancy Wells. Known as 'Nanny the bellwoman', she also fulfilled other roles, including toll collector, watchman and postmistress. Unusually for a town crier, she was unable to read or write. However, her good memory compensated for her illiteracy, allowing her to be 'justly celebrated for the clear and powerful manner in which she announced something "lost," or "stolen," or on "sale by auction".' Highly regarded too for her athleticism, she also helped with capturing prisoners, loading and unloading waggons in the corn market, and delivering letters 'at least within a fortnight after they left the place from whence they were sent'. During George III's visit in the summer of 1788, she came to the king's personal attention while he was walking up the High Street. Having just concluded her message with the traditional words 'God save the King,' George was heard to reply emphatically, 'God save the crier and the people.' Nanny spent the latter years of her life in the Pate's Almshouse, probably at No. 16 Albion Street, which opened in 1811 after moving from its original location on the High Street.

During the nineteenth century, the role of Cheltenham town crier was formalised to some extent through making legal provision for the town's commissioners 'to appoint one or more person or persons to be town crier'. Despite this official recognition and the degree of protection traditionally given to town criers as the king's representative (hence the origin of the phrase 'Don't shoot the messenger'), the role was not without risk of physical danger or abuse. In 1843, for example, a woman was charged with assaulting William Bubb, the then town crier, 'by throwing stones and brickbats at him'. On the other hand, it also formed the subject of the following comic verse included in William Pulleyn's *Church-yard Gleanings and Epigrammatic Scraps* (1830):

'The Cheltenham Crier'
Old Stentor, the crier, had pass'd with his wife
Full thirty long years of contrition and strife:
Her mouth was a bell, and her Billingsgate tongue
In his ears, like a clapper, incessantly rung;
But Pluto, at last, changed the shrew to a ghost,
And whisk'd her away to the Stygian coast.
On the day that her bones were consigned to the earth,
More joyful to him than the day of her birth,
Comes an order, in haste, he should cry through the town,
For a lady's lost dog, the reward of a crown:
When the roaring old blade thunder'd out, 'May I die,
On this day, for his majesty's self, if I'd cry.'

Today, the role's current incumbent is Ken Brightwell, who can be regularly seen wearing the town crier's traditional dress, dating back to the eighteenth century, of a red and gold coat, breeches, boots and a tricorne hat. Ken began his career in 1991. Since then, he has achieved several accolades, including coming second in the European championship and

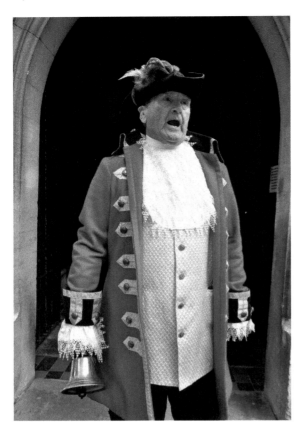

Ken Brightwell, Cheltenham's current town crier.

sixteenth in the world championship competitions. His performances often include a 'cry' about his beloved town, which refers to the fact that Cheltenham holds more festivals than any other town or city, including the oldest cricket festival in the world. Although he uses a bell with no known history, the bell used by the crier to announce the death of Queen Victoria in 1901 is preserved in The Wilson museum.

DID YOU KNOW?
The Cheltenham-born cricketer Gilbert Jessop once damaged a brick (still unrepaired) under one of the eaves of Cheltenham General Hospital after hitting a shot out of the neighbouring college ground. Renowned as a hard-hitting batsman, Jessop scored over 26,500 runs in 569 test matches. Nicknamed 'The Croucher' because of his hunched stance at the crease, he also holds the record for the fastest test century by an England batsmen, scoring 100 off 76 balls in less than one hour against Australia in 1902. Jessop was also an excellent all-rounder, athlete, and even played football for Cheltenham Town.

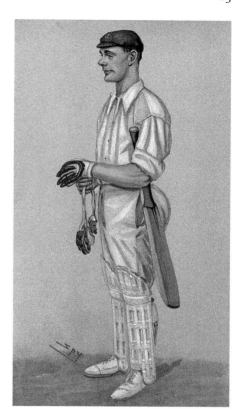

'The Croucher' Gilbert Jessop, remembered as a hard-hitting batsman.

Tradespeople

One of the most interesting memorials in St Mary's Church (now Cheltenham Minster) commemorates Hannah Forty, née Knight (1744–1816), one of the first pumpers at the Old Well. Located near the pulpit, the marble monument was erected by visitors to the spa who were impressed with her 'long and meritorious service'. Starting her duties on 12 September 1772, she continued for more than forty-three years, stopping just seven months before she died on 9 August 1816. Born at Malden, Essex, she married William Forty, a Cheltenham gardener. They lived at Laverham House (formerly Laverham Cottage), No. 77 St George's Place, a villa built *c.* 1790–1820 and now part of St George's Terrace (St James's Square). When she met George III during his visit in 1788, her surname provided the opportunity for the king to reveal his sense of humour. He remarked, 'Mrs Forty, you and your husband together make eighty.' Although Hannah Forty could not afford to drink the spa water that she so ably dispensed, the king was so impressed with her that he commissioned a portrait of her before he left. This is believed to be the earliest picture of a Cheltenham resident. Apart from the portrait, her lasting legacy also consisted of the fact that for some time the Original Well was also known as 'Mrs Forty's Well' because, as one writer put it, 'the venerable old lady having personally officiated at the salutary fountain, and such celebrity had she acquired by her courteous demeanour, that her name was familiar in every quarter of the globe.'

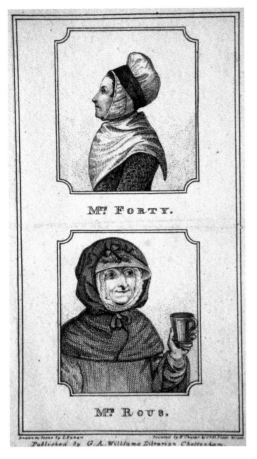

Above left: Hannah Forty (top) who pumped spa water for forty-three years.

Above right: 'Little John' shown selling muffins on the High Street.

One of Cheltenham's most celebrated and intriguing characters during its Regency heyday was 'Little John' (*c.* 1749–1834), an itinerant muffin seller. The diminutive figure, probably only around 3 and a half feet in height, was a familiar sight on Cheltenham's streets and formed the subject of many portrait paintings and caricature drawings. He sold muffins from a large square basket that he carried on one arm, while holding a stick in the other. He wore a tall beaver hat, a black coat or jacket and a white apron that reached down to his feet. Although local children were in the habit of teasing 'Little John', they also kept a respectful distance from him. As one resident recalled, '...if any fresh child could be got who did not know his manner, to go up to him and say "What time is it John?" he would quickly raise his stick and bring it down sharp on his questioner and say "One o'clock!"'.

It seems likely that soon after his death Little John was succeeded by another diminutive. The *Cheltenham Chronicle* records that on 1 July 1844 Henry Clarke, the 'little

muffin man', was given a 15s fine after being charged with deliberately smashing the window of a druggist's store.

Another familiar figure in nineteenth-century Cheltenham was the candy seller Mr Fry (d. 16 May 1833). Known as the 'Dandy Candy Man' his 'Penny an ounce!' cry was well known on the streets. Little is known about him, other than when he died in 1833 he left a 104-year-old mother residing in Sherborne Street. *The English Spy* (1826) includes a small illustration of him produced by Robert Cruikshank, and describes him as being as famous as Jan Mackay, the Cheltenham Dandy (see p. 29–30). It seems probable that Fry also promoted himself as a quack doctor since the book also describes him as 'The cheapest of doctors, whose nostrums dispense / A cure for all ills that affect taste or sense...' and claims that, apart from candy, he was also a London importer of horehound, used in folk medicine to relieve inflammation and aid digestion.

Another memorable nineteenth-century character was Nanny Saunders, nicknamed Nanny, the postmistress. Dressed in a red cloak and large black hat, she carried a wicker basket and lantern. Living a hand-to-mouth existence with her husband and disabled from birth, the couple found shelter in one of the old houses (now demolished) owned by St Mary's Church (now Cheltenham Minster) in the churchyard near Chester Walk. While her husband delivered letters to neighbouring villages with the aid of a donkey,

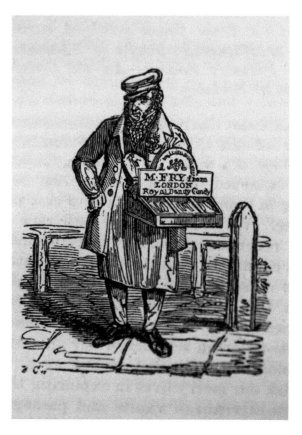

The 'Dandy Candy Man' as illustrated by Robert Cruikshank.

Nanny was responsible during the evening for distributing the mail in Cheltenham once it had been forwarded from the Frog Mill in Andoversford after being dropped off by the London coach. However, Nanny's service was not prized for its efficiency. The Cheltenham historian John Goding recorded that, for some days, an influential resident had been expecting an important letter. After asking Nanny about it, she replied, 'she had something else to do than to bring a single letter to the bottom of the High Street.' When the letter finally reached its destination, it was six days after the London postmark. Nor was this an isolated case. On another occasion, Nanny handed a resident a letter that had arrived in Cheltenham three days earlier, citing her previous excuse for its late delivery!

Another well-known tradesman was Frederick Field (1871–1955). When he retired in 1950 at the age of seventy-nine, it was thought that he was the oldest working chimney sweep in Britain. He lived at a terrace house, No. 43 Sherborne Street, where an unusual zinc sign hanging on the outside advertised his trade. Frederick Field was the last in a succession of chimney sweeps to have lived in Sherborne Street, one of the earliest being John Russell who traded from No. 15 in around 1825. One of sixteen children, Frederick worked for his father, William, also a sweep, from the age of twelve. He took over the family business at just seventeen, and worked as a sweep for over sixty years.

 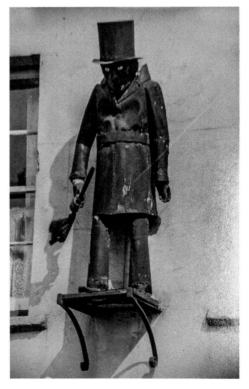

Above left: Cheltenham's postal service, after it became more reliable!

Above right: 'The Old Man' outside Frederick Field's house. (Hugo van Wadenoyen)

The sweep's sign, now on display in The Wilson museum, cast a cold and sinister eye on passers-by in Sherborne Street, and was known to the Field family as 'the Old Man'. Probably dating from the early nineteenth century, it is claimed that it even provoked one frightened night-time pedestrian to contact the police in the belief that someone had hanged themselves outside No. 43. If that did not convey unease, inside the house there was also a number of wooden 'coffins' used as beds where young boys, employed to climb the chimneys and clear them of soot, slept!

Well known as a local character, Frederick was often seen around the town transporting bags of soot on the handlebars of his bicycle to bring them back to Sherborne Street where they were sieved, bagged once more, and sold to local farmers for use as fertiliser. Previously, he accomplished this using a small cart, drawn by a donkey, horse or Shetland pony.

DID YOU KNOW?
One of the favourite pastimes of visitors to the spa was to read the inscriptions on tombstones. Compilations of some of the most interesting appeared in anthologies, such as *Church-Yard Gleanings, and Epigrammatic Scraps* (1829). One Cheltenham example reads, 'Here lies the body of Molly Dickie, The wife of Hall Dickie, Taylor. Two great fisicians first My loving husband tried To cure my pain in vain at last he got a third and then I died.' Another curious Cheltenham epitaph read 'Here lies the body of John Mound, Lost at sea, and never found.'

Eccentrics

One of Cheltenham's most eccentric characters during its Regency heyday was Jan Louis Mackay (1776–1840), better known as 'the Cheltenham Dandy'. Descended from a major of the Scots Brigade living in Utrecht and his wife, who inherited the title of Baroness of Rijnhuizen. Although orphaned at an early age, he received a good education and travelled to Britain, where he settled. When living in Cheltenham he was one of the most conspicuous and instantly recognisable characters on the streets. *The English Spy* described him as a 'placid and agreeable, and ... highly intellectual' figure, with an unmistakeable appearance:

…the old Scotch cloak, the broad-brimmed hat of the covenanter, the loose under vest, the thread-bare coat shaking in the wind, like the unmeasured garment of the scarecrow, and the colour-driven nankeens, grown short by age and frequent hard rubbings; then, too, the flowing locks of iron gray straggling over the shoulders like the withered tendrils of a blighted vine - all conspire to arrest the attention of an inquisitive eye…

If the gossip and first-hand accounts recorded in *The English Spy* are to be believed, Cheltonians considered Mackay a talented individual, 'a writer on finance, and an expounder of the *solar* system', who owned the Vittoria boarding house and was

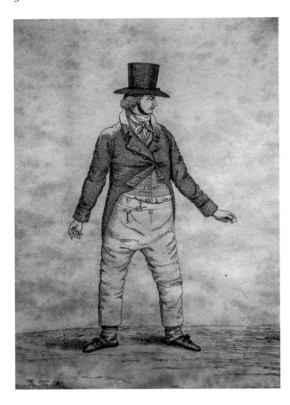

Jan Mackay, better known as
'The Cheltenham Dandy'.

'inoffensive in manners, obliging in disposition, and intelligent in conversation', while also being partial to midnight suppers, which he would instruct his maid to make by simply tapping her on the side with a long cane, without uttering a verbal command. Despite his eccentricities, however, he was also said to be a generous and noble man of principle, as illustrated by the following story recounted in the book:

> During the suspension of payments by one of the Cheltenham banks, and when all the poorer class of mechanics and labourers were in a most piteous situation from the unprecedented number of one pound provincial notes then in circulation, Mr. Mackey [sic], to his eternal honour be it related, and without the remotest interest in the bank, stepped nobly forward, unsolicited and unsupported, gave to all the poor people who held the one pound notes the *full value* for them, reserving to himself only the *chance* of the *dividend*.

Given Mackay's eye-catching appearance he became the subject of several portraits that were widely disseminated as prints, adding to his fame. In these, he is shown wearing a top hat, tartan cloak and loose trousers. In one print he is accompanied by an arrogant-looking, fashionably dressed lady with a muff and pelisse, who has been identified as Mrs Robertson, a shopkeeper friend. However, in 1826 when Mackay was fifty he married Mary Ann Harrison, some thirty years his junior. He died in Tournai, Belgium.

Vladimir Levinski.

In the 1950s, one of the town's most unforgettable characters was the lanky, bewhiskered concert pianist Vladimir Levinski, who, much to the amusement and astonishment of Cheltonians, claimed to be the reincarnation of Franz Liszt. His real name was David Secombe. As Vladimir Levinski he presented himself as a rather odd-looking Edwardian gentleman sporting a monocle, a long black woollen overcoat and jackboots. A highly accomplished, yet temperamental pianist he regularly played for balls at the Cheltenham Town Hall to enthusiastic and often spellbound audiences. His reputation was sealed when, on one occasion, halfway through giving a magnificent concert performance there, he suddenly became displeased and stormed off, throwing sheets of music across the stage as he left. In 1952 he gained brief national recognition when he gave a recital at the Wigmore Hall, at which he styled himself as 'the Paganini of the Pianoforte'. However, it ended in failure when he deviated from the published programme and included controversial arrangements of well-known pieces. In the early '60s, he suffered from health problems and died in a residential home in his thirties.

DID YOU KNOW?
The calculating prodigy George Bidder (b. 1806) once answered some challenging mathematical problems at Cheltenham's Assembly Rooms. In 1817, he gave the correct answer (i.e. 729,571) to the following question in less than one minute: 'If the distance from Cheltenham to London be ninety-seven miles and seven furlongs, and a man steps eight inches and a half, how many steps would he take to London?'

Benefactors

One unusual character who perhaps experienced life's vicissitudes more than most was Miles Watkins (1772–1844), also known as 'the King of the Cheltenham Royal Family'. By luck, at the age of seven, he found some old guineas in a cornfield in Hales Road, which he used to buy a suit of clothes. Then, when looking after a horse near Maud's Elm in Swindon Road, by chance he met the Duchess of Devonshire. After hearing the story

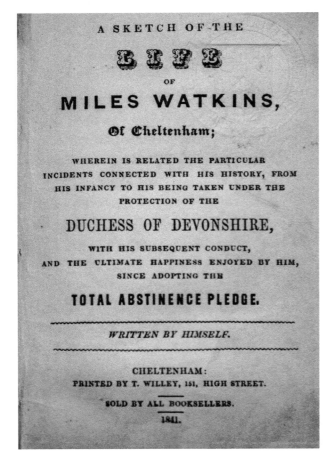

Title page from Miles Watkins' book.

of the elm, she was so impressed with him that she supported his education financially for three years. Afterwards, she invited him to stay at Devonshire House in London for a month and, following his apprenticeship as a shoemaker, acted as patron for his shoemaking business in Cheltenham. Although his business prospered, a combination of heavy drinking and desire to make free gifts to rival a philanthropist called James Webb, led him into difficulty. On one occasion he spent £300 to entertain 600 of his fellow Cheltonians at the White Hart Inn, at the western end of the High Street. As easily as he gained wealth, he lost it again, and at times fell into abject poverty, even being imprisoned for his debts in 1814. In 1841, however, he published *A Sketch of the Life of Miles Watkins Of Cheltenham,* outlining how he gained happiness through becoming a teetotaller.

One of Cheltenham's most well-known characters in more recent years was Ken Hanks (1935–2017). Born in London Road and simply known as 'Dancing Ken' for his love of American country and western music and dancing (he actually changed his name by deed poll to 'Dancing Ken Hanks'), he was always to be seen in town dressed in colourful and flamboyant cowboy costumes, with a smile. Behind the American cowboy persona, however, there was also a tireless charity worker who, over his lifetime, raised up to £1 million for good causes through running country and western shows and dance events. In particular, he felt a close empathy with disabled people, which he developed from an early age through looking after his semi-invalid mother. In later life, he was a volunteer driver for a wheelchair ambulance for twenty-five years. Despite having never visited the USA, Ken transformed his terraced home in Wellington Street into a visual shrine to America, cramming it full with pictures of presidents, guitars, flags and other Americana. He even decorated the exterior of his house and his car with pictures of cowboy and rodeo stars. Ken also stood as a candidate in three parliamentary elections, running (unsuccessfully) for the Monster Raving Loony Party.

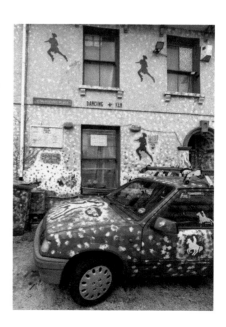

Dancing Ken's house at No. 4 Waterloo Place.

3. Crime and Punishment

Today, virtually nothing remains of the town's early places of punishment. Gallows once stood at the present-day junction of London Road and Hales Road. In 1366 Edward III confirmed that the owner of Cheltenham manor, the abbot of Fécamp, had the right to a gaol. Stocks were also used as punishment from the early Middle Ages until around 1870. Today, two examples are extant in the town: one set adjacent to St Mary's Hall, Charlton Kings, and the remains of a second set now relocated inside Cheltenham Minster. Originally located by the south porch of St Mary's Parish Church, the Charlton Kings stocks were made in 1763. They were possibly used for punishing three men arrested in 1857 for playing pitch and toss instead of attending church. While records show that their punishment was a fine of 3s 4d, plus 3s in costs or three hours in the stocks – it is not known which was served. Whipping posts, used for the punishment of vagabonds and vagrants, were known to have been sited at Arle in 1630. A 1770 map also shows one marked in Alstone Lane. A cucking stool was in existence in 1616, but was absent twenty years later when punishment was being sought for a woman's scolding offence.

One of the earliest prisons in Cheltenham, known as the Blind House, was located in the High Street near an old market hall. It is known that a man died there in 1597. A circular

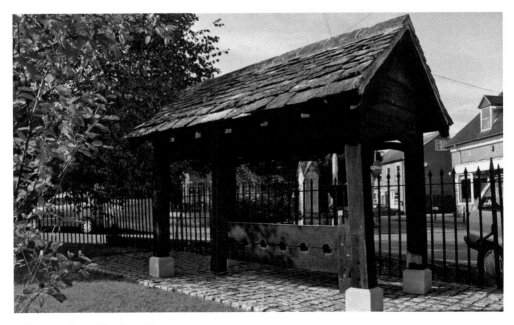

Village stocks at Charlton Kings.

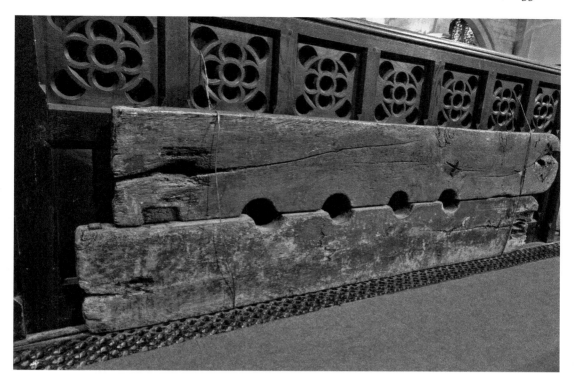

Above: Old stocks at Cheltenham Minster.

Right: The police station when it was located in Crescent Place.

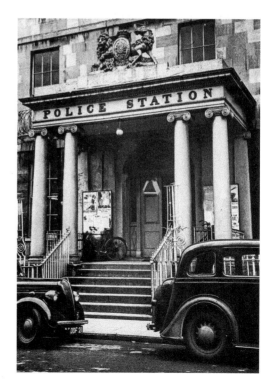

two-roomed stone building, it carried the inscription 'Reader! Do well and fear not'. In 1788, it was replaced by a small lock-up in Fleece Lane (now Henrietta Street), which could hold only one prisoner. 'Through apertures, protected by iron bars', Cheltenham's historian John Goding wrote, 'the inmate held converse with the passers by, and often obtained sums of money, which procured their release.' Adjacent to the Blind House were the stocks, which were often patronised by a local character known as 'Oyster Jack'. Insistent on selling his oysters every Sunday during the hours of church service, he was repeatedly put in the stocks until eventually the authorities lost patience and allowed him to call in peace. A larger gaol was later built on the corner of New Street, which was operational from 1813 to 1840. Subsequent prisons were incorporated as part of police stations, established in various parts of the town, including St George's Place, Crescent Place (in the former Clarence Hotel) and, currently, Hester's Way.

The Sale of Wives

Strange to relate, Cheltenham can furnish examples of this unusual and unlawful practice. Probably begun around the end of the seventeenth century, the 'selling' of a wife allowed people who were unable to afford the costs of divorce to end an unhappy marriage by mutual agreement. Over the years, knowledge of such events seems to have been conveyed as much through fiction as historical fact. The memorable opening chapter in Thomas Hardy's *The Mayor of Casterbridge* (1886), for example, describes Michael Henchard, in a fit of drunken annoyance, selling his wife Susan to a sailor for 5 guineas. In Cheltenham's case it is Isaac Bell, a Charlton Kings-based minor Romantic poet who described himself as 'just a Rhymer', who immortalised one of these incidents through his verse. Unlike Hardy, however, Bell's account, as described in his poem 'On J. Barnes Selling his Wife at Glo'ster: A Fact', can be corroborated through newspaper sources. Bell admonishes that

> ...a man not far from here,
> Who loved not his wife 'tis clear;
> For he to market went one day,
> To sell, or give his spouse away.

He continues,

> But there he could not gain his end,
> It was such funny goods to vend;
> But being on his purpose bent,
> To Glo'ster market next he went;
> Where in a halter there he led
> His loving wife: to me he said,
> He sold her after some suspence,
> For the small sum of eighteen-pence,
> Including one full quart of ale,
> And one full pipe - why, what a sale!

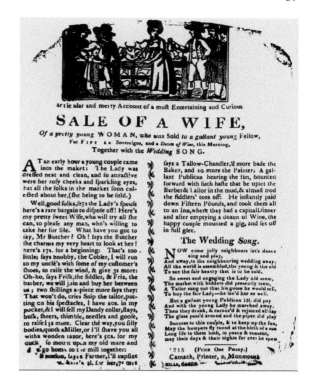

Sale of a wife (nineteenth-century song sheet printed in Monmouth).

The report from the *Cheltenham Journal* of 7 March 1825 provides supporting evidence of the incident, while also underlining that the practice was generally frowned upon:

> On Thursday last (3 March) a woman of the name of Barnes was exhibited for sale in this town; but being considered a 'bad lot', no purchaser was found for such a bargain and she was driven home, with other unsaleable stock (it being market day) unsold. A similar occurrence took place in the neighbourhood of Cheltenham a few weeks since when the enraged populace took the rope from around the woman's neck, and tying the husband to a sign-post pelted him well with rotten eggs &c. to the no small satisfaction of the rustics assembled upon the occasion.

DID YOU KNOW?

A Cheltonian was imprisoned in Cheltenham from 1310 to 1314 for not upholding his promise to marry someone. John Gode was jailed for being 'adjudged as the husband of Juliana Stout, to which sentence the same John refused to comply'. In January 1313, the Prior of Worcester wrote to the Bailiff of the Liberty of Cheltenham ordering Gode's release, since Gode now wished 'to return to a better course of life' and to marry Juliana. However, he was not released until 1314.

Murder

On the east wall of the north transept in Cheltenham Minster, just below the rose window, is a white marble memorial to Katherine A'Court from Heytesbury in Wiltshire who died in 1776 at the age of thirty-two. Erected by her husband and describing her as possessing a virtuous, endearing nature, the memorial appears to be typical of any husband mourning the untimely loss of a young wife, perhaps through childbirth. However, the inscription proceeds to give the precise details about how she died: 'Effected by Poison, Administered by the hands of a Cruelly Wicked Livery Servant Whose Resentment, at being detected in Theft, Prompted him to Perpetrate this horrid and Execrable Crime.'

Like many wealthy families visiting Cheltenham during its heyday as a spa, the A'Courts brought with them an entourage of servants. Among these was a thirty-year-old footman called Joseph Armstrong. They stayed at the York Tavern, a site now occupied by No. 85 High Street. Soon after their arrival, some of their valuables were stolen. Although the robber could not be found, Katherine suspected Armstrong and suggested that he should be dismissed. Then, shortly afterwards, she fell ill and died. The post-mortem examination revealed that 'her bowels were found mortified.' Mr A'Court arranged for Armstrong's belongings to be searched, which revealed that he had been using arsenic. By this time Armstrong had fled, but was soon discovered hiding up a tree near the Frogmill Inn at Andoversford.

Charged with petty treason, Armstrong was put on trial at the Gloucestershire Assizes, at which, eight hours later, it was proven that Armstrong had poisoned Katherine by adding arsenic to her tea and beer. He was then sentenced to be hanged on 17 March 1777 and his body to be dissected. However, before the execution could take place Armstrong succeeded in hanging himself inside his cell with a leather strap. Instead of sending his body for dissection and deprived of the opportunity to put Armstrong on public display for this terrible crime, the authorities decided to chain his body as near as possible to the scene of the crime, thereby acting as a deterrent to other potential criminals. According to John Goding, Cheltenham's first historian, Armstrong's body was hoisted onto a lofty gibbet near Lord Dunalley's house known as North Lodge (now No. 37 St Paul's Road) in an area called 'The Marsh', once popular for rides by the first visitors to the spa. More precisely, it was located 'in the by-lane behind Lord Dunalley's residence, leading to the Marle-hill estate, and in almost a direct line with Dunalley Street and Henrietta Street'.

Around a year later the body disappeared, and it was suspected that Armstrong's Irish relatives, who had recently settled in the town, had taken it away. However, years later when the gibbet posts were being replaced by hedges as part of land enclosures, Armstrong's skeleton and chains were discovered, buried a few feet beneath the surface. According to Goding, the workman who made the discovery was so terrified that he died shortly afterwards, and the skull and bones of the body were purchased by two famous physicians who were visiting the town. As for the gibbet posts, they were used for gateposts at Clonbrock House, now demolished but once located in St Margaret's Road.

Probably the most notorious serial killer associated with Cheltenham was Amelia Dyer, née Hobley (1837–96), a former nurse turned 'baby farmer' who, rather than caring for unwanted babies in exchange for payment, murdered them. In January 1896 Evelina Marmon, an attractive young barmaid who worked at the Plough Hotel (its site

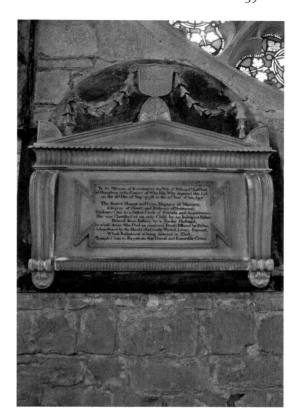

Right: Memorial to Katherine A'Court.

Below: Lord Dunalley's former house, near where Armstrong's body was hanged.

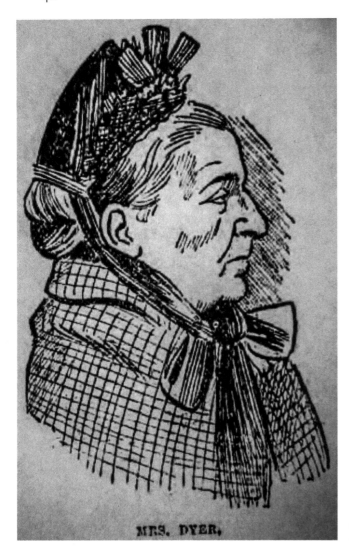

MRS. DYER.

Amelia Dyer. (*Illustrated Police News*, 25 April 1896)

now occupied by the Regent Arcade) and lived at No. 23 Manchester Street (now part of Clarence Street) with Doris, her illegitimate newborn baby, corresponded with Annie Harding, alias Amelia Dyer, in response to an advertisement in the *Bristol Times* offering to adopt a child for £10. Harding wrote:

> l shall be glad to have a dear little baby girl ... one I could bring up and call my own. I must tell you we are plain, homely people in fairly good circumstances. We live in our own house, my husband and I, and have a good and comfortable home. We are out in the country, and sometimes I am alone a great deal. I don't want the child for money, but for company and home comfort. The child would have a good home and a mother's love and care.

Evelina agreed to meet Harding at Cheltenham railway station on 31 March and handed over Doris with a box of clothes in exchange for £10. Evelina had planned to return to work, hoping eventually to reclaim Doris. But less than a month later she gave evidence at the trial of Amelia Dyer after the police found seven dead babies in the River Thames, including Doris who had been strangled with white edging tape and dumped in the river in a carpet bag, weighed down with some bricks, along with another baby. A faintly legible, but decipherable, luggage label gave detectives the vital clue. Evelina wept at the trial, quoting the last letter she received from Harding, which reported, in words now sinister, 'The dear child is well. She slept all the way down, and did not mind the journey.' Dyer pleaded guilty at the Old Bailey on 22 May for the murder of Doris Marmon and was hanged at Newgate Prison on 10 June. Many historians think she may have murdered around 400 babies.

Other Cheltenham-related murders that have made the national headlines include 'The Green Bicycle Murder', which involved the trial of a Dean Close schoolmaster for the murder of a woman. The prime suspect, who used forged testimonials to join the staff at Dean Close, was Ronald Light. He was accused of murdering Bella Wright, a Leicester millworker, after the green bicycle recovered near the murder scene was traced to him. Arrested at Dean Close in 1920, Light was tried in Leicester but later acquitted.

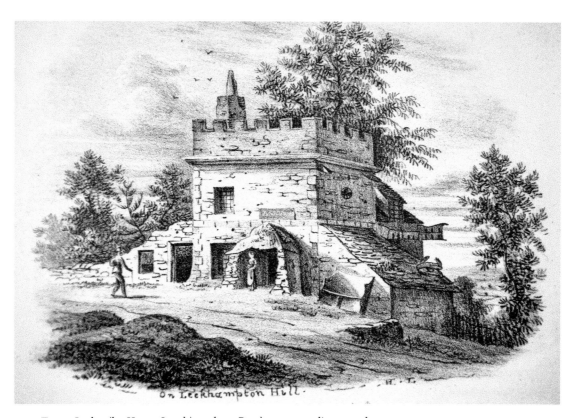

Tower Lodge (by Henry Lamb) – where Butt's coat was discovered.

However, archival records from 2007 provide evidence of a confession for the murder from Light, which he claimed was accidental. Equally inconclusive was the case that became known as 'the Cheltenham torso mystery'. Starting with the discovery of a headless torso in the River Severn near Haw Bridge in 1938, the investigation identified fifty-two-year-old Captain William Butt, resident at No. 248 Old Bath Road in Cheltenham, as the likely victim. Although the murderer was thought to be Brian Sullivan, a twenty-seven-year-old dancer and the son of the nurse who cared for Butt's mother, this was never proven. The case against Sullivan rested on the discovery of Butt's car keys and bloodstained coat underneath the flagstones at the house Sullivan rented at Tower Lodge in Leckhampton. Despite extensive searches, the head and the hands of the body were never recovered. Sullivan, suspected of being Butt's lover, committed suicide two weeks after Butt's disappearance.

DID YOU KNOW?
It's been claimed that a Cheltenham colonel is the real Jack the Ripper. In *Jack the Ripper: British Intelligence Agent* (2010), author Tom Slemen and criminologist Keith Andrews make the case that Colonel Claude Reignier Conder, born in Tivoli and buried at Cheltenham cemetery, was behind the macabre East End killings of 1888. Their claim rests principally on Conder's training as an assassin, a conspiracy theory involving the Metropolitan Police commissioner, who, they allege, covered up the truth to protect a loyal soldier, and Conder's motives, which included killing women who had links with Irish terrorism.

Theft

One of the more unusual cases of theft was recounted by the celebrated actor William Charles Macready (1793–1873) in his diary on 31 August 1836. Macready was a regular visitor to Cheltenham and eventually came to retire here, living at No. 6 Wellington Square from 1860 until his death. On this occasion Macready was staying at the Royal Hotel (now the John Lewis site on the High Street) while rehearsing for a performance of *Virginius* at the Theatre Royal (now the Ladies' College Princess Hall). At the hotel he met his old dresser who used to work for him at Bristol and, it was claimed, had moved to Cheltenham to earn a living doing clerical work. The dresser offered to wait on Macready that evening, which the actor duly accepted. Later, the dresser warned him of recent thefts at the theatre, which he described as 'a sad place'. Macready decided to entrust his purse, watch and ring to the dresser, who promised to stay in the hotel room with the valuables all night. However, upon Macready's return the dresser and the valuables (apart from some keys) had all disappeared. Macready summoned the police, but to no avail. Later, Macready reflected that the dresser was 'a very bad character, living with a common street-walker, and not earning his bread as he stated'. Happily, though, when Macready travelled to Bristol a few days later, he discovered that the thief had sold the ring to a

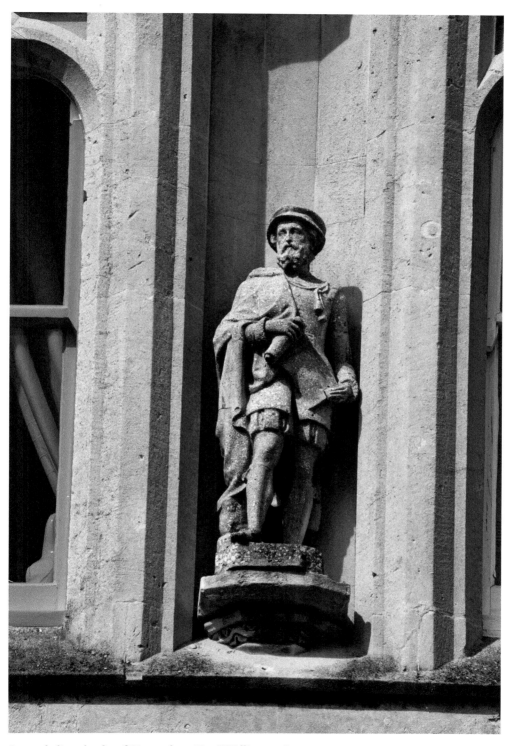

Statue, believed to be of Macready, at No. 6 Wellington Square.

jeweller, and he was able to recover it. In the end, however, the local magistrate ruled that because Macready was unable to attend court sessions to make a prosecution, he had to pay the jeweller 4s – i.e. the price for which the jeweller bought the ring from the thief – to recover it!

'Serious Charge Against a Well-known Cricketer' was the prominent headline in the *Cheltenham Mercury* on 7 June 1886 describing a case heard at the local police court. Also covered in the national press, the case concerned the cricketer Walter Gilbert, a cousin of W. G. Grace who married into the famous Lillywhite cricketing family. Regarded as a fine batsman, good fielder and slow round-arm right-hand bowler for Middlesex, and then Gloucestershire, Gilbert had even toured Australia with W. G. Grace in 1873–74. While living in an age that promoted the amateurs' dictum of Marylebone Cricket Club, namely that 'a gentleman ought not to make any profit from playing cricket,' Gilbert, who did not have a profession and had no private means, was beginning to face financial difficulty. It was this that led to his downfall.

Once having decided to turn professional, in addition to playing for Gloucestershire, Gilbert also started to play as a professional for the minor East Gloucestershire club based at Charlton Park in Cheltenham. However, a spate of thefts from the club's changing room during the early summer of 1886 had prompted the club to set an ingenious trap for the prime suspect, who happened to be Gilbert! The plan involved leaving some marked sovereign and shilling coins in clothes' pockets around the unattended room. All the time, however, the scene was being kept under police surveillance.

Gilbert was caught red-handed stealing the money and admitted his guilt immediately. At the trial, to avoid further disgrace, he asked to be sent to Australia rather than face a prison sentence. However, he was sentenced to twenty-eight days' hard labour at Gloucester Prison and then emigrated to Canada where he continued his career as a fine cricketer. As for the fateful game he played against Stroud at the Charlton Park ground, the official scorecard replaced his name as one of the bowlers with the name 'Smith'!

DID YOU KNOW?
On 21 July 1884 a youth named Edward Green was fined 5s with 11s 6d costs for ringing Mr Vent's doorbell and then running away. The Bench considered him an example of the 'young ruffians who turned the High Street into a bear garden on Sunday evenings'. The Cheltenham-born Chartist and journalist W. E. Adams (1832–1906) also indulged in this trick. He recorded in his autobiography that he collaborated with his friends, who hid in the darkness behind a wall, in repeatedly knocking on doors at night using a piece of string attached to the knocker.

Above: The Old Pavilion, East Gloucestershire Cricket Club, Charlton Park.

Right: View of the courtroom in Cheltenham's Old Courthouse, Regent Street.

4. War and Peace

From the Napoleonic Wars at the beginning of the nineteenth century until the present day, Cheltenham has made a significant contribution to the national effort, both in the provision of military personnel but also in a number of ancillary and supporting roles. In particular, Cheltenham College is celebrated for having a long military tradition. Having both a military and a classical side from its establishment in 1841 until the middle of the twentieth century, it was also one of the first schools to establish a Volunteer Rifle Corps as early as 1862. In 1921 it also achieved the distinction of being one of the few schools to be awarded its own royal military colours, in recognition of the huge sacrifices made by the pupils and masters in the First World War. During that period over 3,540 former pupils served, with 702 losing their lives. In this chapter, particular emphasis is given to some of the most unusual stories relating to the town's military history.

DID YOU KNOW?
A former Cheltenham College pupil was the first man to lead tanks into action. On 15 September 1916 at the Battle of Flers–Courcelette in the Somme, Major Arthur Inglis (1884–1919), a commanding officer of the Glosters, led the 2nd Canadian Division tank regiment on foot, in the traditional way for cavalry commanding officers. Remarkably, Inglis survived his ordeal. However, he died of illness, contracted in war service, in 1919. He is buried in Cheltenham Cemetery at Prestbury and commemorated on the Cheltenham and Prestbury war memorials, and the Cheltenham College roll of honour.

The Napoleonic Wars (1803–15)

Perhaps the most remarkable story from the Napoleonic series of conflicts is that of General Charles Lefebvre-Desnouettes (1773–1822), usually referred to as General Lefebvre, the commander of Napoleon's Imperial Guard Light Cavalry Division at Waterloo, who spent two years on parole in Cheltenham. One of the most handsome of Napoleon's generals, he was captured by the British on 29 December 1808 at Benavente in Spain. A Cheltenham resident, Colonel Macleod of Colbecks, made arrangements for Lefebvre, two other generals and several soldiers to be taken to Cheltenham. Giving his word of honour not to travel more than 3 miles from the town, Lefebvre was lodged at what was then No. 82 High Street (the third house to the east of North Street). Owing to his status and personal charm, he became a popular figure among Cheltenham's

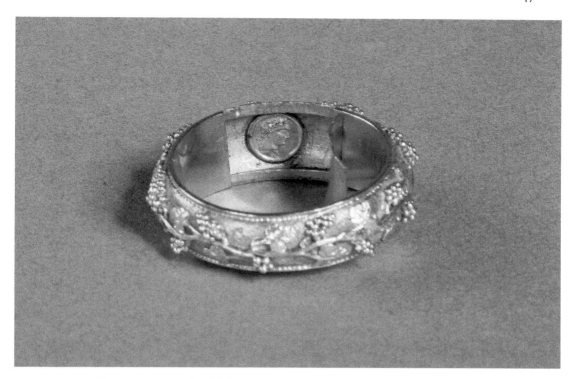

General Lefebvre-Desnouettes's gold ring.

social circles. From February 1811, following Napoleon's approval, his wife also came to Cheltenham. Although a plan was devised to exchange Lefebvre for the Earl of Beverley (then held as a prisoner in France), Lefebvre broke parole and escaped from Cheltenham on 2 May 1812. Disguised as a German count, he was accompanied by his wife, dressed as his son in boy's clothes, and his aide-de-camp, disguised as his valet. The party fled to London and then Dover, from where they returned undetected to France. Lefebvre's plan came to fruition after persuading friends in Cheltenham to lend him large sums of money in exchange for some jewellery. Among the items pledged was a gold ring (now in The Wilson's collections) containing a miniature portrait of Napoleon given to him at the Emperor's coronation. When the local magistrate heard of Lefebvre's escape, he summoned a search party, but to no avail. Later on, Lefebvre continued his distinguished career, including supporting Napoleon's campaign in Russia.

Cheltenham is also strongly associated with the Battle of Waterloo, fought on 18 June 1815. Just over a year later, on 7 July 1816, when Sir Arthur Wellesley, the victorious Duke of Wellington, visited the town, three triumphal arches were erected at the intersection between High Street and Cambray Place. The duke also returned in 1828, visiting the construction site of Pittville Pump Room and, it is claimed, speaking with many of the workmen who were veterans of Waterloo. Today, many memorials to those who fought at the battle can be seen in the crypt of Holy Trinity Church in Portland Place. However, perhaps the most tangible link, apart from the Waterloo medal (in The Wilson's

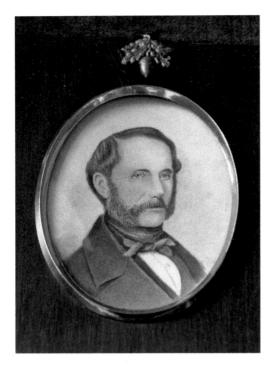

Simon Harcourt, one of the founders of Cheltenham College.

collections) awarded to Captain (later General Sir) Edward Whinyates, is provided through Simon Harcourt (formerly Simon Harcourt Ainslie), one of the founders of Cheltenham College whose red jacket, worn at the battle, can be seen in the college's History Library. His experience of the battle as an officer of the 69th Foot Regiment is vividly recorded in his journal. Now housed in the college archives, it describes how Harcourt, having time only to eat a biscuit for breakfast, bravely led his regiment to defend against a sudden attack by the French cavalry, and eventually gained the upper hand.

Moving to Cheltenham with his six sons in 1839, it was Harcourt who suggested to his friend Captain James Shrubb Iredell, who had retired to Cheltenham from the 15th Bombay Native Infantry, that a school should be established along proprietary lines. A meeting was held in Harcourt's house in Montpellier Villas, which eventually led to the establishment of Cheltenham College in Bayshill Terrace (on St George's Road) in 1841. Two of his sons were among the first students to be admitted, although the family left Cheltenham before the college transferred to Bath Road in 1843.

Crimean War (1853–56)

The Crimean War left its mark on the town in two ways. Injured, returning from the war, were treated at the town's new General Hospital, opened in 1849. Later, a pair of Russian cannons captured at Sebastopol was proudly displayed on plinths in front of the Queen's Hotel. The names of Cheltonians lost in the conflict were inscribed on the pedestal of the Russian trophies, the latter being later removed for use as salvaged scrap metal during the Second World War.

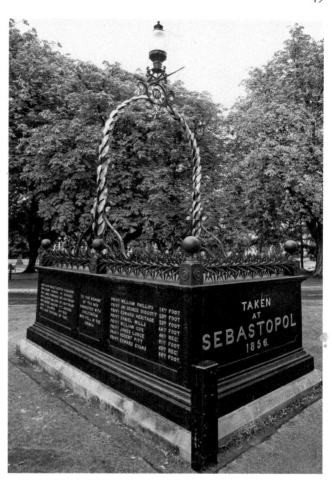

The Crimean War Memorial
outside the Queen's Hotel.

Second Boer War (1899–1902)

At the northern end of the Municipal Offices' Long Garden stands Cheltenham's memorial to the Second Boer War. Unveiled on 17 July 1907 by General Sir Ian Hamilton, the monument records the names of those who lost their lives and those who served during the war. However, one particular incident during the war was also commemorated more recently. In 2007, an Inter-School Field Gun Competition was held between Dean Close School and Cheltenham College based on similar contests held at the Royal Tournament from 1907 to 1999. The event recalls the 118-day siege of Ladysmith, which was lifted on 28 February 1900. Surrounded by Boer forces, the British garrison was given relief support by men of the Royal Navy who, after landing four 12-pounder and two 4.7-inch guns from HMS *Terrible* and HMS *Powerful*, carried them over difficult terrain to provide much-needed fire power. The naval brigade even carried one of the 12-pounder guns for 2 miles after one of the wheels collapsed. Subsequently, this led to displays and, in some cases, competitions of Field Gun Drill, which simulated a naval gun being brought into action during the march to Ladysmith in 1899.

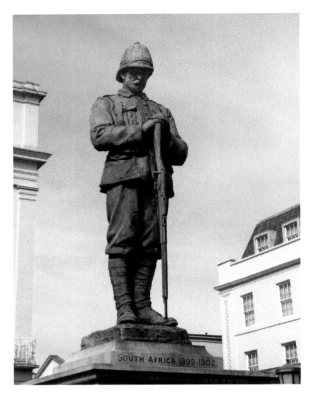

Left: Boer War Memorial, the Promenade.

Below: Field Gun Competition, Dean Close School.

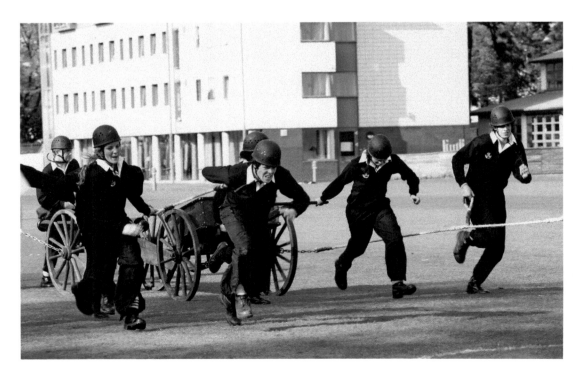

First World War (1914–18)

Many acts of bravery by Cheltonians were recorded during the First World War. Six of the fourteen recipients of the Victoria Cross, who attended Cheltenham College, gained their awards during the First World War. They included Lieutenant-Colonel James Forbes-Robertson who, while commanding the 1st Battalion Border Regiment during the Battle of Lys on 11 and 12 April 1918 near Vieux Berquin, France, saved the Western Line from breaking on four occasions, thereby averting a serious situation. On the first occasion, when British troops were falling back, he led a successful counter-attack to re-establish the line after making a daring reconnaissance sortie on horseback, in full view of the enemy, and under heavy fire from machine guns and close-range shells. After his horse was shot from under him, he continued on foot. On other occasions he succeeded in holding the ground, repeatedly inspiring his men's confidence by his calm composure and disregard of danger. This included incidents when his horse was wounded three times and he was thrown five times and, once again, when a second horse was shot from under him and he continued on foot.

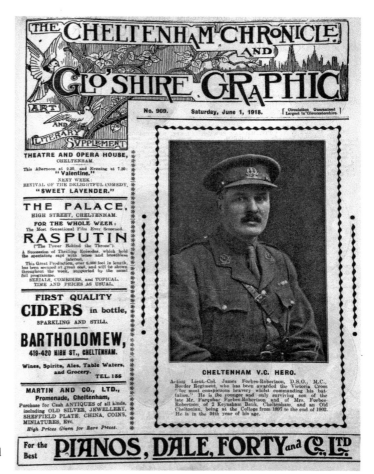

Lieutenant-Colonel James Forbes-Robertson awarded the Victoria Cross.

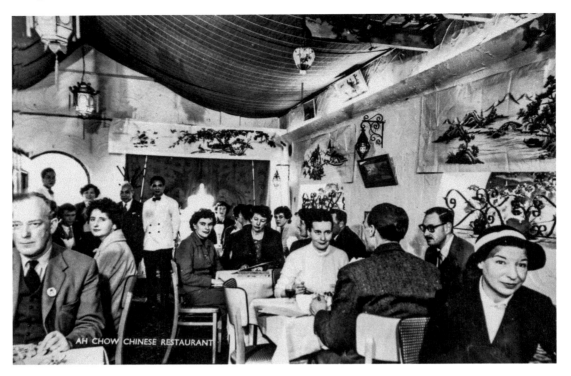

Inside the Ah Chow restaurant, now The Mayflower, Clarence Street.

Another remarkable story of bravery concerns Soo Yow, a native of Toishan, China, who came to live in Cheltenham from 1949, where he established the Ah Chow restaurant, thought to be the town's first Chinese restaurant and which still trades today in Clarence Street as The Mayflower. Soo's wartime experience began at the age of nineteen when in 1916 the French government recruited him in Hong Kong for 'Les Travailleurs Chinois', the French non-combatant Chinese Labour Corps. Contracted to work for five years, working ten-hour shifts seven days a week, he should have avoided life-threatening situations, the work of the corps being limited to building roads, digging trenches, unloading ships and trains and repairing equipment behind front lines. However, he was regularly deployed between 1916 and 1918 to keep an airfield in northern France operational, where he repaired craters on the runway even as it was being bombed! In total, approximately 5,000–10,000 Chinese workers lost their lives as a result of the war, including those with the unenviable task of clearing spent armaments in the aftermath. Over the years the contribution of the Chinese Labour Corps has often been overlooked. In fact, they were literally 'painted out of history' when the Chinese workers, originally included in the famous celebratory painting *Panthéon de la Guerre* (1914–18), now partly preserved in Kansas City, were painted over and replaced by American soldiers because of space constraints on the canvas. Today, their contribution is more widely recognised, including in Cheltenham where a bench commemorating Soo Yow is sited at the main entrance gate to Pittville Park.

Soo Yow, on a French airfield, First World War.

Of the many people in Cheltenham who provided invaluable support on the home front during the First World War, one of the most remarkable stories concerns Mrs Elphinstone Shaw, the wife of an Indian Army colonel, who instigated the Prisoners of War (POWs) Fund in Cheltenham in July 1915. Operating from the basement of her home at Dumfries House in Bayshill Road, in October 1914 Mrs Shaw began sending parcels at her own expense to Cheltenham POWs held in Germany. Apart from sending parcels, which besides food sometimes also contained old boots, warm vests and other essential items such as towels and soap, she maintained correspondence with the soldiers to improve their morale. By the time of her death in December 1917 it was estimated that the fund had raised around £5,000, which supported 197 POWs. By September 1917, as many as seventy parcels per week were being sent. Following Mrs Shaw's death, her daughter and granddaughter continued the work aided by a large team of volunteers, increasing the number of parcels to an average of 1,020 per month.

It is unlikely that this type of support was also available to the forty-two displaced German POWs, described by the *Cheltenham Chronicle and Gloucestershire Graphic* as 'a useful set of men', who were temporarily held in Cheltenham. Arriving in the town on 10 June 1918 to carry out agricultural work in the area, the prisoners were quartered in Charlton House (No. 15 Cirencester Road, now Spirax-Sarco), where the Germans occupied the top floor, and the British guard and officers the lower levels. Among the tasks they carried out was the weeding of Royal Crescent. It was illegal for any help to be given to the POWs, and a Cheltenham woman was fined over £7 in July 1918 for giving one a shilling.

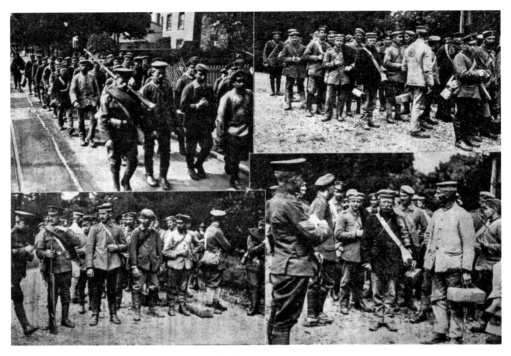

German First World War prisoners in Cheltenham.

One prisoner who failed to survive internment was Stanislaus Bendzmerovski (1892–1918), a member of the 54th Reserve Regiment of the West Prussian/German army and of ethnic Polish origin, who had been taken prisoner near the Eastern Front in December 1916. Put to work on a farm in Prestbury, within around four months of his arrival in Cheltenham he had died from the Spanish influenza pandemic that claimed millions of lives worldwide. Initially, he was buried in Charlton Kings cemetery, but in the early 1960s his body was reburied in Cannock Chase Military Cemetery where approximately 4,500 Germans are now interred, including other German POWs from the Second World War originally buried in Cheltenham Cemetery.

DID YOU KNOW?
It's thought that the first Briton killed in the First World War was a Cheltonian. In *Meeting the Enemy* (2013) historian Richard van Emden claims that Henry Hadley, a fifty-one-year-old man from Cheltenham, was the conflict's first British casualty, just three and a quarter hours after Britain declared war against Germany. It is claimed that Hadley was teaching English in Berlin on 3 August 1914 when, realising his imminent danger, he quickly caught a train to Paris. However, he was shot by a Prussian officer and died of his wounds at 3.15 a.m. on 5 August.

Second World War (1939–45)

Today, Cheltenham is commemorated as the birthplace of Sir Arthur Harris (1892–1984). Known as 'Bomber' Harris, the commander-in-chief of RAF Bomber Command, born at No. 3 Queen's Parade, coordinated the strategic bombing campaign against Germany from 1942. Two years earlier, Cheltenham suffered its worst losses during a German bombing raid. On 11 December 1940 twenty-three people were killed and 120 injured when ninety-seven high-explosive and hundreds of incendiary bombs were dropped on the town. Initially striking the Gloucester Road-based Sunningend factory of H. H. Martyn & Co. Ltd, which produced parts for the manufacture of Hawker Hurricanes at the Gloster Aircraft Company's Brockworth site, the planes dropped bombs along the axis from the Pilley area of Leckhampton to Tewkesbury Road. Sixty houses were destroyed and 1,800 damaged, leaving 600 people homeless. There was extensive damage in Stoneville Street, where ten people were killed, as well as in Lower High Street, Merriville Road, Kipling Road, Parabola Road, Exmouth Street, Montpellier Villas, Shurdington Road, Victoria Place, Christ Church Road, Suffolk Road and St Margaret's Road. The hall of residence for St Mary's Training College in The Park was also hit. In Leckhampton, three people in a bungalow at Maida Vale were killed. Pilley Bridge was also destroyed.

Another significant raid occurred on 27 July 1942 when four bombs were dropped by a lone raider. Eleven people were killed in Brunswick Street and twelve houses destroyed. Another 400 houses were damaged, while nearby St Paul's Training College in Swindon

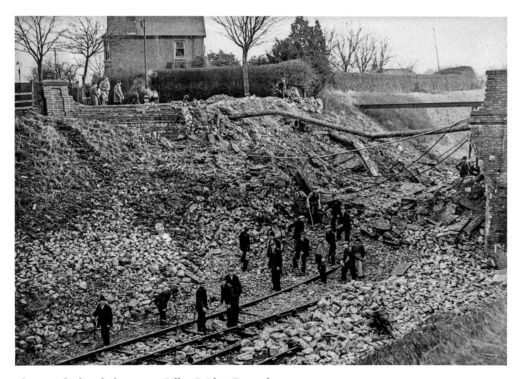

Clearing the bomb damage at Pilley Bridge, December 1940.

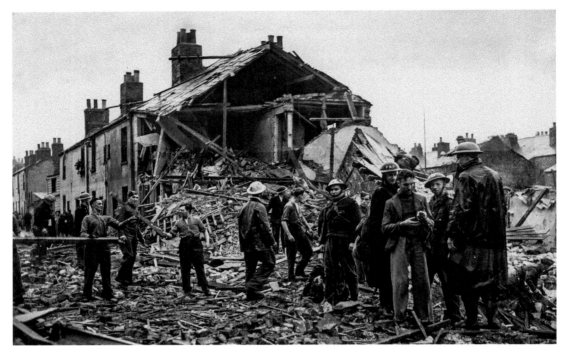

A baby duckling, found alive in Brunswick Street, July 1942.

Road had a narrow miss. The back of Dunalley Parade was also hit, but without loss of life. In the aftermath of the raid, police discovered £1,000 in £1 notes in one of the ruined houses, and a duckling was found, still alive, in the rubble. Nine days later, Queen Mary made a morale-boosting visit to meet the residents.

Among Cheltenham's less well-known links with the war was Cyril Kenneth Bird (1887–1965), one of the most talented wartime propagandists and a Cheltonian by birth. After attending Cheltenham College in 1902–04, he studied engineering while also pursuing his preferred career as an artist. During the First World War he served as an officer in the Royal Engineers, but suffered serious back injuries when he was blown up by a shell at Gallipoli. While recuperating, he produced cartoons for various magazines, including *Punch*, which helped to establish his future career as a cartoonist and journal editor. To avoid confusion with another *Punch* contributor whose surname was Bird, he adopted the pseudonym 'Fougasse', the name for a basic French landmine of unpredictable performance. Later, he compared the 'Fougasse' mines with his cartoons, noting that their effectiveness was 'not always reliable' and their aim not always certain.

Nevertheless, the distinctive simple linear style that he developed as a cartoonist, coupled with his strong use of humour, brought him considerable success. He once reflected that 'it is really better to have a good idea with a bad drawing than a bad idea with a good drawing.' His ideal was a cartoon that did not need a caption.

During the Second World War he worked entirely voluntarily for the Ministry of Information, using his humour to create some of the most effective propaganda images

Right: One of eight propaganda posters produced by Fougasse.

Below: A Camouflaged Runway by Cedric Kennedy.

of the Second World War. His memorable 'Careless Talk Costs Lives' series of posters became instantly recognisable, earning him a CBE in 1946.

Another artist who contributed to the war effort was Cedric Kennedy (1898–1968). Kennedy was art master at Dean Close School from 1938 to 1960 except when, interrupted by the war years, he became one of the camouflage staff, often known as 'camoufleurs', at the secret Civil Defence Camouflage Establishment (CDCE) located at Leamington Spa. Tasked with developing camouflage to protect strategically important sites such as airfields, factories and power stations, in 1941 the CDCE was renamed the Directorate of Camouflage (part of the Ministry of Home Security) after being expanded to include a Naval Camouflage Section.

Work to provide camouflage and concealment was necessary while daylight raids continued. Using photographs or sketches made from the air, the camouflage officers developed plans to either hide sites or create adjacent decoys to divert enemy aircraft. Three-dimensional scale models were developed for important sites so that the designs could be tested under laboratory conditions using different lighting and atmospheric conditions. Naval camouflage presented greater challenges given the constant movement of the vessels against a continuously changing background, coupled with the visibility of smoke emanating from funnels and wake created by hulls. Again, scale models were used to develop the most effective schemes to provide disguise or cause confusion, tailored to the weather conditions likely to be encountered in different environments.

Global Footsteps, previously known as The Rendezvous Society.

Although best known as a landscape painter, who studied at the Royal Academy, perhaps Kennedy's most important legacy are the wartime camouflage paintings now housed in the Imperial War Museum. As a lieutenant who served during the First World War with the Royal Flying Corps, Kennedy was also an accomplished pilot. The combination of his flying and artistic skills made him ideal for working at the Directorate of Camouflage, which brought approximately 250 artists, designers and technicians together to work in secret on elements of military and civilian camouflage.

Peace

Against a background of continuing local conflicts, efforts have been made in the town to promote a lasting world peace. In 1985, for example, the educational charity the Rendezvous Society (now renamed Global Footsteps) was founded in Portland Street. As an organisation promoting engagement with people of other cultures, its philosophy is based on winning people's hearts as a way to create mutual understanding and enduring peace. Among its projects have been the establishment of 'friendship town' links with Kisumu in Kenya from 1985 and a deepening of the links with Sochi, Cheltenham's twin town in Russia, through initiating exchange visits in 1989.

DID YOU KNOW?
Percy Jeeves, a Warwickshire cricketer killed on 21 July 1916 during the Battle of the Somme, inspired P. G. Wodehouse's fictional character 'Jeeves'. Wodehouse saw Jeeves play at the Cheltenham College cricket ground on 14 August 1913, and later commented, 'I suppose Jeeves' bowling must have impressed me, for I remembered him in 1916, when I was in New York and just starting the Jeeves and Bertie saga, and it was just the name I wanted.' Ironically, Wodehouse's first story about Jeeves appeared in print just a matter of weeks after Percy Jeeves perished.

5. Reform and Revolution

Cheltenham has often been associated with the promotion of freedom and rights. In the early 1840s, for example, the utopian socialist John Goodwyn Barmby (1820–81), who claimed to have coined the term 'communism', set up an agricultural commune in Cheltenham. This commune, one of only five – the others being located in London, Ipswich, Merthyr Tydfil and Strabane in Ireland – encouraged people to give up individual wealth and embrace communal living. More recently, in 1984 the town became associated with the second longest continuously fought dispute in British Trade Union history when the government suddenly ordered GCHQ workers to leave their Trade Unions, and initially led to a protest meeting of 1,500 GCHQ workers at Pittville Pump Room.

Rights of Way
In 1902 and 1906 Leckhampton Hill was the scene of a major test for the protection of traditional rights of way. The hill had long been considered a popular place of leisure and somewhere that locals were free to wander. This was the case throughout the early nineteenth century when the Trye family of Leckhampton Court owned the hill and used

Destroying the Fences. (*Battle of Leckhampton Hill*, 1902–04)

Tramway Cottage in ruins. (*Cheltenham Chronicle and Graphic*, 26 July 1902)

it as a quarry for extracting freestone. In 1894, however, the Trye family sold the hill to Henry Dale, a businessman who lived at Daisybank House at the foot of the hill. Despite the fact that the locals regarded the hill as common property and the paths as being free for all to use, Dale fenced off parts of the land and blocked all the footpaths. Keen to develop the quarries, he also built a cottage, known as Tramway Cottage, for his quarry foreman on a site that the villagers previously used for bank holiday fair attractions.

Following Dale's action, there was widespread local displeasure. Dorothea Beale, principal of Cheltenham Ladies' College, for example, ordered the removal of the school pianos that had been hired from Dale's firm, Dale, Forty Company, which once traded on the Promenade. On 8 March 1902 several hundred protesters gathered on Leckhampton Hill after marching from the Malvern Inn, and tore down some of the fences. This action was repeated on Good Friday and on 7 July, after which four ringleaders (known as the 'Leckhampton Stalwarts') appeared in court. Following their acquittal on 15 July, the four stalwarts, together with a crowd of around 2,000 people, became so incensed that they demolished Tramway Cottage. However, Dale immediately had it rebuilt. Further protests and skirmishes took place, focusing on a 16-acre piece of land where the paths had been fenced off, and culminated on Good Friday (13 April) 1906 when, after breaking down and burning the fences, an angry mob started to destroy the cottage again. This necessitated the reading of the Riot Act by

Above: Reading the Riot Act outside Tramway Cottage, 13 April 1906.

Left: A cartoon from *Cheltenham Chronicle* and *Graphic*, 15 March 1902.

HEARD AT LECKHAMPTON.

FOND MOTHER : Tommy, I've been looking for you; where have you been?

TOMMY (triumphant): O! only up on the Hill to down Dale!

a local magistrate, George Witts, who lived at Hill House, Leckhampton. Eight people were arrested. After being found guilty of creating a riot and attempting to demolish Tramway Cottage they were sent to Gloucester Prison to do hard labour. However, their sentences were reduced by one third after a petition of 9,000 signatures was sent to the Home Secretary.

Among those convicted was Walter Ballinger, one of the 'Leckhampton Stalwarts' who later became a corporal in the Gloucestershire Royal Engineer Volunteers during the First World War. Leaving for the front on 6 January 1915, Ballinger told the *Gloucestershire Echo*, 'I'm off to fight for what I'm not allowed to walk over.' Five months later, writing from France, he remarked:

> When I see the barbed-wire entanglements here, I am reminded of the narrow paths with a wire fence either side to keep to the footpath on Leckhampton Hill! The fight we had for the people's rights; but we were defeated. Today we are fighting a different foe, and we will never quit the field until we have conquered this foe.

Ballinger survived the war and returned to live within sight of his beloved Leckhampton Hill. He was present at the ceremony in September 1929 when, following the decision by the town council to buy the 400-acre hill estate and open it to the public, the protesters eventually achieved success.

Animal Rights

One of the societies that campaigned against the ill treatment of animals was the Cheltenham Ladies' Society for the Protection of Animals (CLSPA). Founded in 1872 with similar aims to those of the older Royal Society for the Prevention of Cruelty to Animals (RSPCA), the CLSPA campaigned for the welfare of horses, dogs and other animals. Its members looked after strays and ran a dogs' home in Whaddon. However, their lasting legacy was the installation of drinking troughs primarily for horses and cattle at strategic entry points throughout the town. A total of five were constructed. Today, the four that survive, all constructed from Aberdeen red granite, provide attractive street furniture and are commonly used as flower troughs.

The drinking troughs met an important need at a time when the only alternative was for draught animals to be watered at inns. The earliest surviving trough was originally installed in 1878 at the Gloucester Road/Tewkesbury Road junction. This was later transferred to the Promenade, opposite Martin's the jewellers. The other three, dating from the early 1880s, are located at Pittville Gates, the Hewlett Road/London Road junction, and at the bottom of Leckhampton Road outside the Norwood Arms.

Efforts to protect birds have been made by some notable Cheltonians and visitors. The town's most accomplished bird conservationist was Dr Edward Adrian Wilson (1872–1912). Although remembered principally as the explorer, artist and scientist who perished with Captain Scott at the South Pole, he should also be recognised as one of the country's greatest campaigners for the protection of birds.

In 1905, for example, following the launch of a new industry boiling penguins for their oil, he spoke out against the practice at a meeting of the Royal Society for the Protection of Birds and the International Ornithological Congress. This eventually resulted in

CLSPA drinking trough outside the Norwood Arms.

CLSPA drinking trough, Pittville Gates.

the trade being banned. Another major achievement was his discovery of a pest that threatened to eradicate grouse stocks on the moors of northern Britain. Through his research, conducted between 1906 and 1907, which involved dissecting over 2,000 birds to analyse their crop contents and intestines, he identified the cause of the disease, a small thread worm that was infesting the dew drops of the heather. Without this pioneering research it is doubtful whether red grouse would still be inhabiting Britain's moors. However, perhaps his greatest legacy was that he possibly inspired the development of the twentieth century's greatest conservationist. As Captain Scott was dying by Wilson's side at the South Pole, he wrote a letter to his wife Kathleen. In it, inspired by Wilson, Scott wrote of his hope for the future of their son, Peter: 'Make the boy interested in natural history if you can,' he said 'it is better than games; they encourage it at some schools.' The result was Sir Peter Scott, who grew up to be one of the twentieth century's leading conservationists, founding the Wildfowl and Wetlands Trust at Slimbridge and the World Wide Fund for Nature.

Another pioneering bird conservationist with strong connections with Cheltenham was Edmund Selous. Moving to Cheltenham in 1901, he lived at No. 19 Clarence Square, the former home of the explorer Charles Sturt, from where he regularly went birdwatching in nearby Pittville Park. Unusually for his time, Selous came to view the practice of killing birds (often as specimens) as 'something monstrous and horrible'. Instead, he developed a keen sense of observation and published several pioneering studies of bird behaviour based on his field notes. In one, he expresses his disappointment with Cheltenham Corporation, which he criticises for eradicating some beautifully coloured Muscovy ducks he was studying at Pittville Park because the authorities considered them a 'mongrel lot'. He added wryly that they were replaced by 'a few pairs of select, blue-blooded strangers (more soothing to gentle bourgeois feelings)...' On another occasion, in 1905 (two years before he left Cheltenham) he protested against a proposal in London to destroy starlings under the mistaken belief that they were harming songbirds. Writing from Cheltenham, he cited his own experience and knowledge that songbirds 'are as indifferent to the starlings as the starlings are to them,' and, quoting Darwin, called upon 'all naturalists with souls' to protect the starling roosts.

Workers' Rights

One incident from 1870 provides interesting insights into the plight of the working-class population, without which Cheltenham's development as a fashionable town would not have been possible. The case was brought by Edward Brydges, the clerk of the borough council, although its real instigator was probably Julia Jeens, the head dressmaker at a milliner's shop at No. 13 Promenade, which specialised in making dresses and costumes 'by competent hands in the Newest French Styles'. In January 1868, the 1867 Workshop Regulation Act came into force, limiting the working hours of employees in small workshops through bringing them into line with equivalent provisions made for factories a decade earlier. This meant that workshops with more than five employees had to limit the working hours of women and children to a maximum of twelve hours per day. Additionally, they could not employ workers on Sundays or after 2 p.m. on a Saturday.

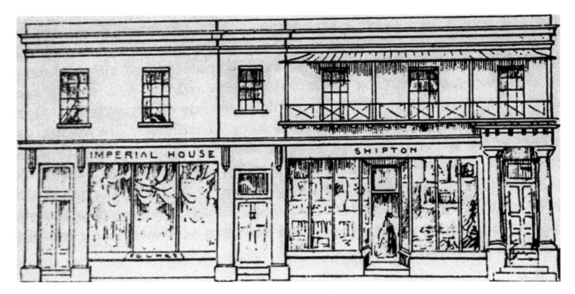

Thomas's shop, No. 13 Promenade (previously trading as Shipton).

In January 1870, Brydges received an anonymous letter, encouraging him to do 'a great kindness on the part of the dressmakers by inspecting Miss Thomas, 13 Promenade after 5 of a Saturday evening, there the young people are kept in an underground place till 8 or 1/2 past...' On Saturday 14 May, Brydges arranged for the Inspector of Nuisances to visit the premises during the evening, where he discovered nine young women still at work. Although Rebecca Thomas, the owner of the shop, was a respected businesswoman, Brydges decided to enforce the Act and prosecute her. At court, on 14 June, three of the workers, including Julia Jeens, gave evidence against their employer. This revealed that they usually worked 8 a.m. to 8 p.m. six days a week, but sometimes until 9.30 or 10 p.m. During busy days they would even work until just before or after midnight. The court found against Rebecca Thomas and she was fined £1 plus costs. Subsequently, most of the nine women originally identified by the Inspector of Nuisances left Thomas's employment. Thomas herself continued with the business until 1888 when, in her late fifties, she was able to retire.

Women's Rights

One of the country's most important campaigners for women's rights was Josephine Butler (1828–1906). Following her husband George's appointment as vice principal at Cheltenham College, she lived in 1857–66 at The Priory, a large, eight-bedroom Regency house (now redeveloped as Wellington Mansions) on the corner of London Road and Priory Street. When the Butlers moved to Cheltenham, the couple shared in the excitement of George's new job. 'I think we shall like Cheltenham,' Josephine commented to a friend, 'It is pleasant being connected with so flourishing an institution.' Further excitement followed when Josephine gave birth to a daughter in May 1859. Named Evangeline Mary after the heroine of *Uncle Tom's Cabin*, Eva had a lively and engaging personality.

Wellington Mansions, site of The Priory
where the Butlers lived.

However, in 1864 the Butlers suffered a terrible tragedy. One evening, Eva, then aged six,
fell from the banisters when she was running to greet her parents and died in her father's
arms. Josephine blamed herself because she had previously rebuked Eva for being late for
tea. Eva was buried at St Peter's Church in Leckhampton.

This tragic experience proved a turning point in Josephine's life and, following the
Butlers' move to Liverpool in 1864, she wrote that she 'became possessed with an irresistible
urge to go forth and find some pain keener than my own, to meet with people more
unhappy than myself'. In Liverpool she began groundbreaking work to fight for women's
rights, in particular campaigning against their degrading treatment under the Contagious
Diseases Acts. Under these laws, women could be apprehended and examined at will,
helping to institutionalise the belief that making use of prostitutes could be condoned,
despite considering the women providing these services as immoral. In later years, when
she returned to Cheltenham, she even uncovered unsavoury facts about prostitution
in the town and the use of *maisons tolérées*. 'There are low class brothels and slums,'
she wrote, 'which would be a disgrace to London or New York'. Her righteous anger was
particularly aroused when her landlady asked a prostitute living in rooms below her to
leave. 'In this correctly Evangelical Cheltenham,' she wrote, 'they are all so comfortable –
so properly Evangelical that they catch you up if you pronounce a single word which is

not pure low-church shibboleth.' Angered by the lack of help being provided by the local churches, she even thought about laying 'a train of gunpowder here' to which God might put a spark!

In 1886, Josephine's campaign finally achieved success with the repeal of the Contagious Diseases Acts. Thereafter, she established the International Abolitionist Federation to combat similar systems across Europe. Josephine's remarkable courage and achievements in highlighting the plight of 'fallen women' and revealing the double standards of male legislators should not be underestimated, particularly at a time when it was unknown for respectable women to talk about sex, let alone sexually transmitted diseases. Towards the end of her life, while she recorded having a 'curious & comforting feeling of companionship in being so near Eva's grave', there is no doubt that the terrible tragedy that occurred in Cheltenham in 1864 perhaps formed the most significant turning point in her life.

Eva Butler's grave at St Peter's Church, Leckhampton.

A more unusual group seeking reform towards the end of the nineteenth century was the Western Rational Dress Club. Established in February 1897 at Elborough Cottage (now No. 36 Cudnall Street) in Charlton Kings, the club sought to promote the benefits of more comfortable and practical, and therefore more 'rational', clothing for lady cyclists. The use of conventional dress for cycling, which at that time included several layers of petticoats, full-length skirts, tightly laced corsets and tailored blouses and jackets led to regular accidents, which not only resulted in embarrassment, but also potential disfigurement and even death.

The club was formed by Maude Mary Buckman, who became the club's captain, and her husband, Sydney Savory Buckman, a well-known geologist who acted as secretary. It was supported by Lady Harberton as club president who, in 1883, had established the Rational Dress Society (later known as the Rational Dress League). Drawing inspiration from the ethos of similar national and regional groups, the club offered three categories of membership: members, who always wore rational dress for cycling; associate members who only committed to doing so on an occasional basis; and associates who sympathised with the idea, while not putting it into practice. The objectives of the club were threefold:

1. To promote a dress-reform whereby Ladies may enjoy outdoor exercise with greater comfort and less fatigue.
2. To advocate the wearing (particularly for Cycling) of the Zouave or Knickerbocker Costume, as adopted by the ladies of France, Germany and America.
3. To take all necessary steps, in connection with kindred Associations in London, to encourage this desirable reform.

To support the club's aims the Buckmans collected details of local accidents caused by lady cyclists wearing inappropriate garments. One recorded in 1897 described how a Cheltenham lady who was cycling to Gloucester had to be rescued 2 miles later by two gentlemen after her skirt got caught. Unable to dismount, her skirt had to be cut off to free her. Her bicycle was also destroyed in the process, necessitating her journey to be completed by train and leading the *Gloucester Citizen* reporter to conclude that 'The only safe dress for cycling is knickerbockers'!

Another accident from 1897, this time reported in the *Daily Mail*, described how two young ladies were riding side by side in the Lansdown area of Cheltenham. Being very windy, the skirt of one blew into the wheel of the other, where it got caught, causing them both to somersault. After being helped up, their skirts were nearly taken off. The eye-witness commented, 'well, I found it necessary to look the other way.' Although the Western Rational Dress Club disbanded in 1899, the national rational dress movement continued to make progress, eventually merging with the suffragist cause at the beginning of the twentieth century.

Given Cheltenham's strong associations with radical movements during the first half of the nineteenth century, it is perhaps not surprising that, after Bristol, the town became the major hub for women's suffrage in Gloucestershire. As early as August 1839 women were involved in suffrage activism in Cheltenham when female Chartists staged a 'sit-in' at St Mary's parish church. On this occasion, the evangelical preacher Revd Francis Close

Elborough Cottage, where the club was established.

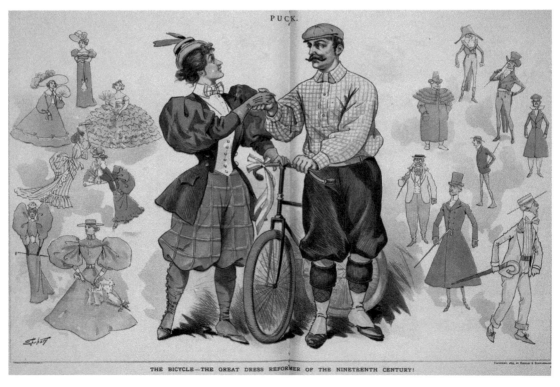

Nineteenth-century bicycle dress reform.

likened the women to 'sisters of the French Revolution' who, he considered, 'became more ferocious fiends than even the men themselves; plunged more deeply into crime; glutted themselves with blood; and danced like maniacs amidst the most fearful scenes of the Reign of Terror!'

On 12 May 1869 Cheltenham's first women's suffrage petition was presented to Parliament, probably sparked by the Municipal Franchise Act, which extended the vote to single and widowed female ratepayers in local, but not national, elections. Another petition was signed two years later at a public meeting, which led to the creation of the Cheltenham branch of the National Society for Women's Suffrage. One year later, Cheltenham Corn Exchange became the venue for a lecture on 'The Electoral Disabilities of Women' given by Rhoda Garrett, a significant figure in the early years of the suffrage movement. 'We only ask', she stated, 'that women who fulfil the same conditions as men – who are householders, who pay taxes, and are rated to the relief of the poor, shall be admitted to the franchise. More than this we do not ask – at present.'

The subsequent story of women's suffrage in Cheltenham is one largely conducted through peaceful protest. On 2 April 1911 this included refusal to complete census returns as part of the Women's Social and Political Union (WSPU) civil disobedience campaign. In Cheltenham it was Florence Earengey, née How (1877–1963), a resident of No. 3 Wellington Square in Pittville from 1899 to 1911, who coordinated local activity of the Women's Freedom League (WFL) in parallel with the WSPU call that 'if we don't

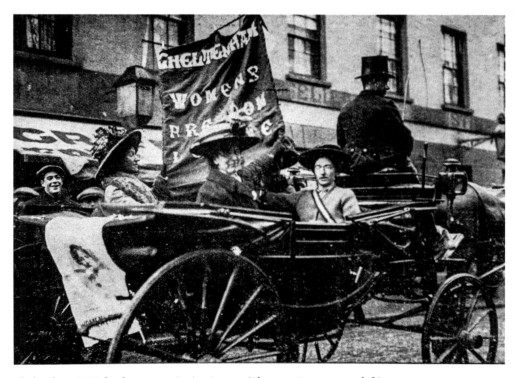

Cheltenham WFL leaders campaigning in 1910 (Florence Earengey on left).

count, we won't be counted.' Prior to her husband recording himself as the sole occupier, Florence promoted census evasion, publicising her opposition to the mayor who was concerned that the tactics might jeopardise Cheltenham's chances of acquiring county borough status through not reaching the necessary 50,000 population figure.

Another supposedly peaceful protest, known as the Women's Suffrage Pilgrimage, was organised by the National Union of Women's Suffrage Societies (NUWSS). Starting in June 1913, the march set out along six main routes to converge in London. On 15 July the Cheltenham contingent proceeded along Lansdown Road to make its way to the Clarence Street Lamp, a traditional meeting place for outdoor addresses. However, an angry mob rushed their vehicles as they made their way through the town and then disrupted the meeting with hand bells. Under the headline 'Cheltenham Disgraced' the *Cheltenham Chronicle* reported, 'Respected citizens … engaging in a constitutional manner, were assailed with vegetables in varying stages of putrefaction, and eggs and epithets equally vile, and had their meeting broken up in disorder without a single speech having been delivered.' In the end, although the police erected a barricade in Wellington Street to hold back the mob, the women were forced to seek safety at the police station.

Two of the suffrage leaders involved were Rosa Swiney, the Calcutta-born president of the Cheltenham Women's Suffrage Society (WSS), and Theodora Mills, WSS secretary between 1902 and 1918, who lived at Lowmandale, Leckhampton Road. Mills was also a talented songwriter who wrote five propaganda songs, including 'Rise Up Women! For the fight is Hard and Long' and 'The Women's Battle Song' sung to the tunes of 'John Brown's Body' and 'Onward, Christian Soldiers' respectively.

Rosa Swiney speaking at the Clarence Street Lamp in 1911.

At the beginning of the twentieth century, some members of the suffrage movement, later known as 'suffragettes', changed their tactics towards more militant activity. In Cheltenham this manifested itself at first through mildly aggressive activities such as chalking pavements with 'Votes for Women' slogans and refusing to pay the subsequent fines, attaching posters to pillar boxes and, in August 1913, placing a bomb (assumed to be a hoax) with a 'Votes for Women' slogan at the entrance of the Town Hall. However, on 21 December 1913 a more serious incident occurred. The suffragette Lilian Lenton (1891–1972) and another woman, probably Olive Wharry (1886–1947), caused fire damage to a large unoccupied house, Alstone Lawn, once situated at the junction of Gloucester Road and Alstone Lane. When apprehended in Tewkesbury Road, traces of paraffin on their stockings, boots and cloak provided crucial evidence to support their conviction. After giving their names in court as 'Red' and 'Black', they were sent to Worcester Gaol, from where they were released under the Prisoners Temporary Discharge for Ill Health Act 1913 (popularly known as the 'Cat and Mouse Act') after going on hunger strike. The women absconded after failing to reappear at Cheltenham on 29 December.

'Red' and 'Black' exiting
Cheltenham Police Court after
the guilty verdict.

DID YOU KNOW?

In 1884, the Indian social reformer Pandita Ramabai Saraswati (1858–1922) studied and taught Sanskrit at Cheltenham Ladies' College? A close friend of Dorothea Beale, she later wrote her seminal book *The High Caste Hindu Woman* (1887), which gave voice to the plight of Indian women. Two years later, Ramabai established a school, known today as Mukti Mission, for destitute women from all castes in Poona (now Pune). By 1905 Miss Beale was so impressed with Ramabai's work that she contributed £20 annually to the school, which, at the time, supported around 1,800 women.

Right of Freedom of Religion

From the seventeenth century, Nonconformity played a significant part in Cheltenham's religious life. Despite the large number of people advocating religious freedom, therefore, it is perhaps surprising to discover that Cheltenham once exhibited extreme religious intolerance when an anti-Catholic riot was held in the town. Occurring around the time of the Papal Aggression, anti-Catholic sentiment in the town was already running high as a result of the strongly held beliefs of Revd Francis Close, the town's long-serving evangelical preacher. As a disciple of Charles Simeon, Close opposed Catholicism. He even revived the Guy Fawkes Day church service to promote his brand of Conservative Christianity and stoke anti-Catholic views.

Following the issuing of the papal bull on 29 September 1850, recreating the Roman Catholic hierarchy in England, a large meeting was held at the Old Town Hall (now the site of the Regent Arcade car park). However, such was the interest in attending it that, according to *The Times*, 'hundreds, if not thousands' had to be turned away, leading to a second meeting being arranged on 21 November. Prior to this, effigies of the pope and Cardinal Wiseman were put on display in a tailor's shop (located then at No. 372, now No. 176, High Street) owned by Mr Hardwick. While it is thought that Hardwick had used the occasion as a publicity stunt for his business, the crowds who gathered to view the effigies were led to believe that they were to be publicly burned after being paraded around the town.

As crowds gathered at the shop during the night, they demanded the effigies. However, Hardwick was unwilling to hand them over since, earlier on, local magistrates had forbidden any anti-popery processions. Nevertheless, after the crowd smashed around forty of Hardwick's and other shops' windows and started throwing fireworks around, he handed the effigy of Cardinal Wiseman over to the police, who stripped it of its fine clothes and passed it to the angry mob. They then carried it through the streets as far as the Roman Catholic chapel (today the site of St Gregory's Church), where, after making a bonfire by tearing down wooden fencing, it was ceremoniously burned. Further destruction was caused by smashing the windows of the chapel and premises known to belong to Roman Catholics. It was not until after midnight that order was finally restored after police armed with cutlasses arrived. Possibly partly fuelled by this incident, the

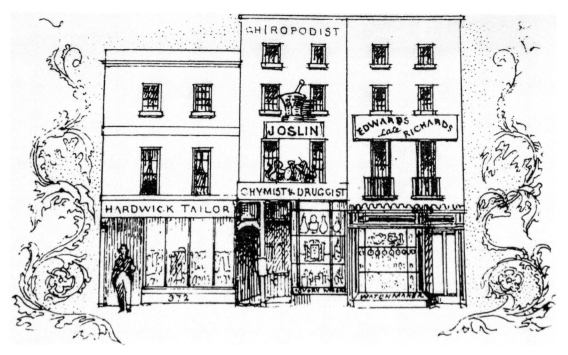

Hardwick's shop (left) which displayed the effigies (George Rowe, 1845).

Catholic population in Cheltenham grew in number. Soon the Catholic chapel proved too small for the congregation, leading to plans for a new church to be built. In 1857 the result was St Gregory's Church, which was, notably, opened by Cardinal Wiseman. Significantly too, at 208 feet high its new spire ended up surpassing that of the parish church by 41 feet!

DID YOU KNOW?
The Victorian poet Elizabeth Barrett was horrified that a new religious sect called the Third Revelation was being established in Cheltenham in 1844. Writing in a letter about her own interest in mesmerism, she refers to 'a religious sect at Cheltenham, of persons who call themselves advocates of the "third revelation", and profess to receive their system of theology entirely from patients in the sleep.'

6. Hidden History

Throughout the nineteenth century Cheltenham was recognised as an attractive place for wealthy families, many of whom had served in the colonies, to settle. Despite this, much of the town's Anglo-Indian heritage and its connections with black history, including slavery, have, to some extent, formed part of its hidden or forgotten history. Today, however, particularly in the light of recent new research, a clearer understanding of how the town's colonial past has shaped its development can be gained.

Links with Slavery

Although Cheltenham's connection with slavery is less recognised than in cities such as Bristol, Glasgow and Liverpool, in many cases the wealth that built the town came from sugar plantations in the West Indies. One of the earliest examples was Dame Frances Stapleton, who owned plantations and estates in the islands of St Christopher (St Kitts) and Nevis. Moving to Cheltenham as an absentee sugar planter, she built the Great House *c.* 1739 on the site of Cheltenham's former medieval Manor House (previously the site of St Matthew's Church). This became the first lodging house to accommodate visitors to the newly developed spa.

Another significant beneficiary of slavery-derived wealth was James Robert Scott, the original owner and architect of Thirlestaine House in Bath Road, who spent nearly

Thirlestaine House whose construction probably came from slavery-derived wealth.

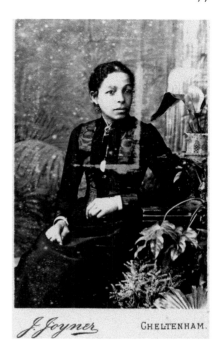

Unknown woman of colour photographed in Cheltenham (*c.* 1865–1908).

£100,000 on its construction between 1823 and 1831. Much of this almost certainly derived from his inheritance of a share in four estates in Jamaica from his uncle William Chisholme, who died in 1802. Also of significance was William Hinds Prescod (1775–1848) who, by 1820, lived at Alstone Lodge (later renamed Alstone Lawn). During the 1830s Prescod became the largest slave owner in Barbados, with 1,738 slaves on nine estates. While never acknowledging it publicly, he was also suspected of fathering four mixed-race children with a free black woman, one of whom, Samuel Jackman, became an outspoken critic of the Barbadian plantocracy and the first non-white member to serve in the Barbadian Parliament. Other large houses in the town with slavery associations included Trowscoed Lodge in Leckhampton Road and neighbouring Fairfield House. Both have since been demolished.

One noteworthy family with strong connections both with slavery and Cheltenham was the Barretts. One family member, Samuel Barrett (known as 'Handsome' Sam), owned the Spring Estate in Jamaica, a fact that can be confirmed through visiting his memorial in Holy Trinity Church. His famous niece, the poet Elizabeth Barrett Browning, whose father changed his surname to Barrett at the behest of his grandfather in order to inherit estates in Jamaica, believed that her family was cursed through accruing wealth from slavery. She frequently visited relatives in Cheltenham, and on one occasion was accompanied by a former slave from her family's Jamaican sugar plantation. However, her writing, as exemplified both in *The Runaway Slave at Pilgrim's Point* (1849) and her poem *A Curse for a Nation* (1854), show her strong anti-slavery views.

Overall, the extent of Cheltenham's links with the slave trade can perhaps be best gauged through searching the database recently created by the Centre for the Study of

the Legacies of British Slave-ownership, established at University College London. In this, fifty slave owners are identified who lived in Cheltenham, owning nearly 10,000 slaves between them. Following the abolition of slavery in the British Empire in 1834, the government paid out a total of £20 million to the slave owners in compensation for their loss of income, the equivalent today of approximately £17 billion. Around 46,000 claims were processed for 800,000 slaves, each one categorised according to their value in different classes. The Cheltenham-specific compensation claims range from payments made for as little as £168 15s 7d for seven slaves in Jamaica to approximately £37,285 for 1,738 slaves owned by William Prescod.

Further analysis shows that many of the plantocrats and rentiers congregated in exclusive areas of the town, particularly Lansdown, Bayshill, Montpellier, Tivoli, Pittville and The Park. Lansdown Terrace appears to be of particular significance where, over a period of just eight years, a wide range of connections may be discerned. Among the early residents, well before the terrace was fully completed in 1848, were Isaac Baruch Lousada and his daughters (at No. 1), whose relatives owned plantations in Jamaica and Barbados; Sir Ralph Darling (at No. 7), who as governor of Mauritius objected to slavery on moral grounds; Catherine Henrietta Best (at No. 9), whose husband helped to suppress the largest slave revolt in Barbadian history; Charles Darling, who died at No. 10, having previously been governor of Jamaica where he viewed black people as being prone to public disorder; the widow of Hon James Holder Alleyne (at No. 11), whose husband owned 579 slaves on five estates in Barbados; and Eleanor Jopp (at No. 22), whose husband co-owned a slave ship and who received £300 in compensation for the seven slaves she owned in Jamaica.

Other tangible links are also revealed through the choice of house names. Samuel Bradford Cox (1772–1838), for example, named his residence in Thirlestaine Road Zeelugt House (now owned by the Cobalt Trust and renamed Linton House) after the Zeelugt estate, which he owned in British Guiana. Solomon Mendes da Silva, who owned 327 slaves on six estates in Jamaica, later became an active member of the Jewish community in Cheltenham. Here, he lived at Park Place between 1837 and 1843 in a house called Rioho Lodge (now No. 16), named after his Jamaican plantation.

While detailed records do not exist for the slaves themselves who ended up living in Cheltenham, burial and baptism records reveal some of their names, occupations and origins. Among these were Romeo Hamilton ('a negro') and Mingo ('a black man'), who were buried at St Mary's Church (now Cheltenham Minster) in 1810 and 1817 respectively. Others were James Hudson ('a Negro') and Margaret Walden (a 'person of coller') who were baptised at St Gregory's and St Mary's churches respectively in 1816 and 1817. Baptisms at St Mary's also recorded in 1828 that a boy called Samuel was the son of Madagascan slaves, and in 1831 that an orphan called Jane Ross was born into slavery at the Cape of Good Hope, but was now the servant of Major Robertson.

The lengthy debates, which took place both at national and local levels between those who supported slavery, and those against it, also played out in Cheltenham. One early visitor to the town who opposed slavery was Jane Harry, later Thresher (c. 1756–84). The mixed-race daughter of Thomas Hibbert, an English plantation owner, and Charity Harry, a freed mixed-race Jamaican, Jane (or Jenny as she was often known) was born

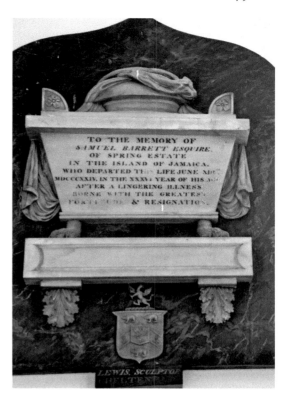

TO THE MEMORY OF
SAMUEL BARRETT ESQUIRE.
OF SPRING ESTATE
IN THE ISLAND OF JAMAICA,
WHO DEPARTED THIS LIFE JUNE XIII
MDCCCXXIV, IN THE XXXVI YEAR OF HIS AGE
AFTER A LINGERING ILLNESS
BORNE WITH THE GREATEST
FORTITUDE & RESIGNATION.

LEWIS, SCULPTOR

Right: The memorial to 'Handsome' Sam in Holy Trinity Church.

Below: The Quakers' burial ground entrance in Grove Street.

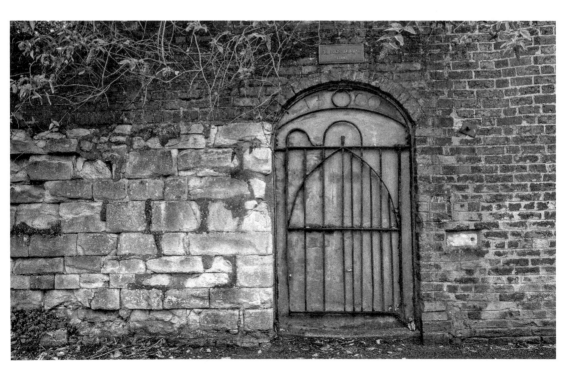

in Kingston, Jamaica and sent to England for her education around 1769. Placed under the guardianship of Nathaniel Sprigg, Hibbert's former slave-trading partner, Jane visited Cheltenham in the 1770s with the Sprigg family. Although a short visit, it proved of great significance. In Cheltenham she interacted with the town's Quaker community, following which she decided to change her religious allegiance from Anglicanism to Quakerism. While conversion to Quakerism came at the cost of losing the Sprigg family's protection and friendship, it probably contributed to her desire, following the death of her father in 1780 and her mother's inheritance of the estate, to return to Jamaica to free her family's enslaved workers. In a single decade, from 1764 to 1774, her father had imported over 16,250 African slaves with his new business partner. However, the war with the American colonies made it too dangerous for Jane to travel to the Caribbean. Nevertheless, before she died at the age of twenty-eight following childbirth, she requested that her husband pay the necessary fees to liberate her mother's slaves. In 1787, when the organised movement in Britain against slavery and the slave trade began through the creation of the Committee for the Abolition of the Slave Trade, Harry was hailed as one of the early abolitionists, three years after her obituary appeared in *The Gentleman's Magazine* telling her remarkable story.

Another early reformer who spoke out against the injustices was the Revd John Thorpe, a curate who practised in Jamaica between 1826 and 1829. The eye-witness testimony he gave at a public meeting in Cheltenham on 7 October 1830 provided clear evidence of a corrupt, inhumane system. Nevertheless, abolitionists' views such as Thorpe's were challenged by the publication of pro-slavery treatises. Among these was *Plain Facts; or the Question of West India Slavery, Seriously Examined by the Test of Truth, and Real Observation*, a book by Nathaniel Sotham, the third edition of which was published in Cheltenham in 1825. Sotham's aim was 'to undeceive the *misinformed*, at the same time to teach the *uninformed*' about the true nature of West India slavery. His arguments included assertions that 'negroes ... feel themselves transplanted into the bosom of comparative ease and luxury, from a state of hopeless barbarism' and that they enjoy privileges that are 'very little, if at all inferior, in rank or comfort, to the lower general class of labourers in Great Britain'.

Some of the diehard sentiments of slavers who settled in Cheltenham after selling their estates were also perhaps reflected in a vitriolic, satirical letter published by 'Nathaniel Thresher' in *Punch*. Written in 1846, the year Parliament removed the sugar duties that had previously protected British producers in the domestic market, 'Thresher' claimed to be a plantation owner who settled in Cheltenham after working his Mount Pleasant estate in Berbice, British Guiana, for eighteen years. In the letter he criticised the government for 'the iniquitous emancipation of the black fellows' in 1833 who, following their freedom, only work for two days a week, and accused his black workers of being 'the idlest vagabonds ... [who lacked] respect for the rights of property and the interests of their employers'.

Despite this, many enlightened views also prevailed. George McLean, for example, who lived at Malcolm Ghur (now Pillar House) in Bath Road and owned 1,051 slaves on twelve estates in Grenada, is remembered as a liberal landlord who pioneered the practice of allowing his slaves the freedom to tend their own gardens once they had completed a set

PLAIN FACTS;

OR THE

QUESTION

OF

West India Slavery,

SERIOUSLY EXAMINED

BY THE

TEST OF TRUTH,

AND REAL OBSERVATION.

THE THIRD EDITION.

With a Dedication to the English Nation.

BY NATHANIEL SOTHAM.

CHELTENHAM:

PRINTED BY S. Y. GRIFFITH AND CO. CHRONICLE OFFICE ;

AND SOLD BY ALL BOOKSELLERS.

1825.

Right: Sotham's book which challenged abolitionists' views.

Below: Pillar House today, previously owned by George McLean.

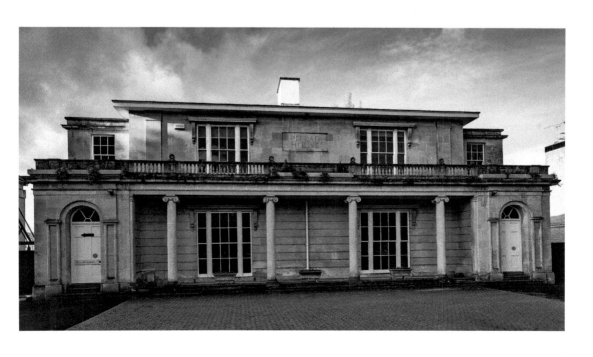

daily task, a practice later followed by other estates. Major-General de Symons Barrow, who came to live at Courtfield, Charlton Kings, in 1885, is reputed to have been the son of the first owner to free his slaves before emancipation became law; while Charles Gray, who owned 220 slaves on two estates in Tobago, made provision for two female servants to be freed in his will (proved in 1827). In Cheltenham, a public meeting held at the Assembly Rooms on 4 March 1841 formed the Cheltenham branch of the Society for the Extinction of the Slave Trade and Civilisation of Africa. The Revd Francis Close chaired the meeting, which moved to view 'with feelings of the deepest horror, the increased amount and misery of the Slave Trade and fully [acknowledged] the national obligation of attempting its suppression'. In 1864 a minor local poet, James Downes Jelf, was even moved to publish a twenty-seven-page-long poem in Cheltenham entitled 'The Evil of Slavery' aimed at 'vindicat[ing] the RIGHTS OF FREEDOM, and put to shame, Tyranny, Oppression, Serfdom, and Wrong'. An excerpt from the poem reads:

> There are, who use the lash, throughout the day,
> And the poor branded victim maim and flay,
> Just as a worn-out hack, is hurried on,
> Till death o'ertake him, and his toil be done.

Lives of Black People

Cheltenham's reputation as an important centre for education has also led to its connection with some unusual and remarkable black people. In 1870, this included Prince Alemayehu Tewodros (1861–79), the son of the Ethiopian emperor Tewodros II, who attended Cheltenham College as a pupil under the care of the Revd Thomas Jex-Blake, the then principal. The child prince, whose ancestry could be traced back to King Solomon and the Queen of Sheba, became orphaned in April 1868 when his father, unwilling to accept defeat during the British conquest of Magdala, committed suicide and his mother died from an illness. Originally, the British conflict with Abyssinia arose after Emperor Tewodros II wrote to Queen Victoria seeking an alliance with Britain to help protect Ethiopia from the Ottoman Empire and Egypt. However, because the letters were written in Amharic, no one in the Foreign Office could read them, and so the letters were ignored. Eventually, the emperor became angry, not only banishing all Britons but also throwing the British consul into prison.

Having been captured in the aftermath of the battle, Alemayehu was made a ward of Queen Victoria and sent to Cheltenham to receive a public school education. Here he was looked after by the Jex-Blake family, which included nine daughters. In another poignantly tragic example of communication failure the prince's grandmother wrote to Cheltenham College in Amharic on 12 January 1870 inquiring about the health of her only surviving grandson, imploring him to write back to her, and advising him to act astutely by making friends with powerful kings and queens, so that he could act wisely for the people of Abyssinia. Sadly, the letter was returned because no one could read it.

Although the prince, who accompanied the Jex-Blakes when they transferred to Rugby School, did not excel academically, in 1878 he went to Sandhurst to train as an officer. However, in October 1879 he died from pleurisy at the age of nineteen and was buried

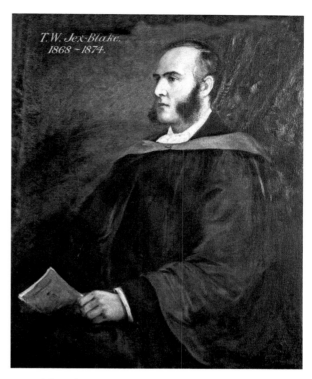

Above left: Prince Alemayehu Tewodros. (Photograph by Jabez Hughes)

Above right: Revd Thomas Jex-Blake, Prince Alemayehu's guardian in Cheltenham.

at Windsor Castle. When news reached Cheltenham of the prince's untimely death, the *Cheltenham Chronicle* commented, 'He will not sleep less soundly because English daisies grow over his grave instead of the acacias of Abyssinia.' It continued, 'All that can now be said to mitigate sorrow for his early fate is that he had the kindliest treatment here, that he made troops of friends, and that his last hours passed amidst comforts and solaces which the wild pomp of Abyssinian Court life could never have furnished.' In contrast, Queen Victoria noted in her journal, 'It is too sad. All alone in a strange country, without a single person or relative belonging to him. His was no happy life.'

Another remarkable story belongs to Victoria Davies (1863–1920), the first black pupil to study at Cheltenham Ladies' College. Davies was eighteen when she arrived in Cheltenham in the spring term of 1881, and stayed for at least one year. Her mother, originally known as Aina but later named Sarah Forbes Bonetta Davies, came from the Egbado Omoba tribe, now the Yewa clan of the Yoruba tribe in Nigeria. In 1850 a naval officer was sent by Queen Victoria to try to persuade the King of Dahomey to curb the slave trade in his kingdom. On his departure, the king gave an orphaned girl, who had lost her family in a massacre, as a present for Queen Victoria. She was so impressed by the girl's regal manner and her academic and artistic abilities that she gave her an allowance. When Sarah later gave birth to a daughter the queen granted her permission

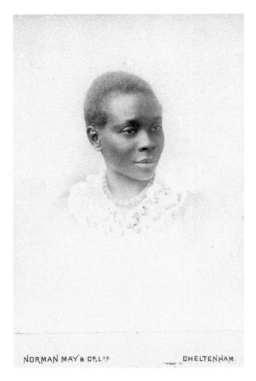

NORMAN MAY & C⁰,LT⁰ CHELTENHAM. Victoria Davies.

to name the child Victoria. The queen made the child her goddaughter, describing her as 'A lively intelligent child with big melancholic eyes'. After Sarah died at around forty, the queen became responsible for Victoria and paid up to £100 a year for her to be educated at Cheltenham Ladies' College.

According to the college pupil Cecily Steadman, Victoria was a 'source of much pleasant interest and excitement'. One account described how she 'could climb like a monkey', on one occasion even scaling the roof of one of the houses, and causing much anxiety for her safety. On another, during a hot summer's day, after finding her restrictive European clothing quite uncomfortable, she is said to have arrived for class wearing only a loose nightdress and a pink sash. A friendly, confident girl, she followed her mother by excelling in music. After passing an elementary music exam she even petitioned the queen to ask Miss Beale, the college principal, to grant the school a day's holiday. Despite being disproportionate to the achievement, Miss Beale complied with the request. Victoria was also proud of her African heritage and is recorded as writing messages in Yoruba when she stayed at nearby Sudeley Castle in 1882 and 1889. A letter sent from Cheltenham in 1882 also records Victoria's sincere concern for Queen Victoria's safety following an assassination attempt by Roderick Maclean in March. In later life, Victoria married John Randle, a Nigerian doctor, in Lagos. Subsequently, she had two children, and remained in touch with the royal family for many years. She also became acquainted with the famous black composer, Samuel Coleridge-Taylor and supplied him with a Yoruba folklore song, 'Oloba', which he included in his book of black melodies published in 1905.

DID YOU KNOW?
Eddie Parris (1911–71), Wales' first black footballer, played for Cheltenham Town FC in 1946. Born near Chepstow, following his family's migration to Wales from Jamaica, Parris represented his country against Northern Ireland in December 1931. A talented left-winger, he was the first black player to appear in international championship in Football League history.

The Anglo-Indian Connection

Around 3 per cent of Cheltenham's current population is categorised as Asian or Asian-British, many of whom migrated to Britain between the 1950s and the 1960s. However, the town's connection with the subcontinent actually dates back as far as the first half of the nineteenth century when the term 'Anglo-Indian' referred to British people who had either worked in India or been born there. While Cheltenham, once famous for its 'curry and colonels' and 'Asia Minor' reputation, became a favourite retirement place for Anglo-Indians during the second half of the nineteenth century, little detailed attention has been given to this group. In one recent study, however, a database of nearly 1,200 people, compiled from census and other records, revealed the significant influence that this community exerted on the town. Nearly 90 per cent had worked as Indian and British army and naval officers, while just over 10 per cent was employed in the Indian Civil Service or as medical officials.

Tablet commemorating a retired Indian civil servant, Holy Trinity Church.

Initially, Cheltenham attracted Anglo-Indian visitors at the beginning of the nineteenth century because its springs were considered beneficial to digestive system disorders, including those caused by oriental food and climate. From the middle of the nineteenth century, however, when Anglo-Indians were looking for retirement homes, the town, already familiar from previous visits, proved attractive because its climate was considered similar to that of Simla, the summer capital of the British Raj. Many of them congregated in exclusive areas of the town, particularly Bayshill, Lansdown, Montpellier, Pittville and The Park.

Much information about the town's Anglo-Indians can be gleaned through the memorials that are still visible, especially in Christ Church and Holy Trinity Church, and the records of Cheltenham College, which was established in 1841 with careers in the military or East India Company Civil Service in mind. Among the memorials of Christ Church are Lieutenant-Colonel Charles Pratt Kennedy (d. 1875), who founded Simla, and James Webster (d. 1858) who, following the 'nabob' (referring to the *nouveaux riches* who returned from India) tradition, made a vast fortune in India. After serving in the Madras Army Webster became a successful businessman. Returning to Britain in 1836, he initially lived at Lake House (No. 91 Pittville Lawn) before purchasing the twelve-bedroom Hatherley Court mansion five years later, where according to the *Cheltenham Looker-On*, he 'thus acquired a territorial qualification to the rank and station which his ample wealth entitled him to maintain'.

More evidence of Anglo-Indian associations can be seen through house names. Charlton Manor (on Ashley Road), for example, which was the first house to be built

Mosquito Ghur, now an Indian restaurant in Bath Road.

The Calcutta Inn.

on the Battledown estate, was originally called Simla Lodge, while Nos 22–29 Lansdown Road were previously known as Mussoorie Court, after the Mussoorie Hill station in Uttar Pradesh. Two other noteworthy private residences were Mosquito Ghur (now an Indian restaurant at No. 143 Bath Road) – *Ghur* being the Hindi word for house – and Malcolm Ghur (now Pillar House) located nearby. Also, a public house dating from the 1830s called the Calcutta Inn once stood at the corner of Gloucester Road and St Georges Road. It was demolished in 2003 and has now been replaced by the St George's Gate flats.

Although most records detail the lives of white British people, the Anglo-Indian connections also led to a significant number of Indian natives coming to stay in the town. Many of these were employed by British families as nannies or nursemaids known as 'ayahs' (deriving from the Portuguese word *aia*, meaning 'nurse' or 'governess'). Initially established by the eighteenth century, the practice of employing Asian nannies continued well into the twentieth century. An advertisement in the *Gloucestershire Echo*, for example, on 13 February 1920 from a woman staying in Oriel Terrace, sought an ayah (or amah) to look after two children on a forthcoming voyage to Penang.

Prior to India gaining its independence in 1947, British families often went home on furlough to escape the summer heat between March and October. On these journeys they employed either their existing ayahs or recruited travelling ayahs to look after their children and luggage. However, following their arrival in Britain, the travelling ayahs, numbering around 140 per year by the 1850s, were often discharged without arrangements made for their return journey. Consequently, some decided to settle in Britain. Others, as illustrated by numerous advertisements in the *Cheltenham Looker-On*, particularly between the 1860s and 1880s, had to promote their services for a return passage to India. Desperate to secure this, some even stated that their wages were 'unimportant'. One intriguing story about a Cheltenham ayah relates to Ruth, an adult native of Madras, who was employed to look after Colonel and Mrs Rowlandson's children during their return to

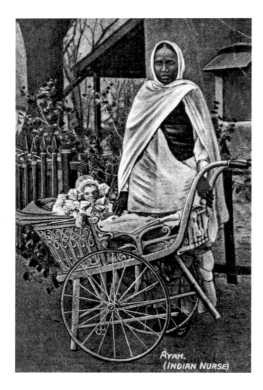

AYAH.
(INDIAN NURSE)

Ayahs in Cheltenham desperately sought 'free' return passages to India.

the town from India. Records from Christ Church reveal that she was baptised on 26 July 1882, the same day as her youngest charge, Julia Rowlandson. While the resident vicar officiated for Julia, a Tamil-speaking minister, the Revd Robert Pargiter, carried out the separate service for Ruth.

Lives of Colour

The stories included in this chapter from Cheltenham's black and Anglo-Indian history form a small part of the town's wider hidden or forgotten history relating to its cultural diversity and heritage. In October 2018, a new organisation known as Lives of Colour was set up in Cheltenham with the purpose of providing 'an inclusive platform where people can "own their voice" regardless of their gender, religion, age, disability, ethnicity or sexual orientation', with the aim to build the infrastructure for a more inclusive and resilient society. Founded by Florence Nyasamo-Thomas, who was born in Kenya and moved to Cheltenham during the 1990s, the organisation also plans to record communities' current history so that the concept of 'hidden or forgotten history' will no longer be relevant. The story of Florence Nyasamo-Thomas's own life deserves to form part of that history. Through her desire to understand the society adopted as her new home she has galvanised support to improve diversity awareness and inclusion in Cheltenham society, not only through establishing the African Community Foundation and Black History Month project in Gloucestershire but also through her work as a trustee for Global Footsteps (see p. 58–59).

Florence Nyasamo-Thomas, founder of 'Lives of Colour'.

DID YOU KNOW?
The Ethiopian Emperor Haile Selassie (1892–1975) visited Cheltenham in July 1937, when he toured the Ladies' College, the Pittville Pump Room, the Lido and the Montpellier medicinal baths. After lunching at the Queen's Hotel, he also sampled the Pittville water from the Central Spa. In January 1940, just five months before his reinstatement as emperor, he made a return visit, this time to see an artist friend's exhibition at the art gallery.

7. Firsts

Over the years, many remarkable developments and unusual events have occurred in Cheltenham. In some cases, these have been of a truly pioneering nature. In the early 1930s, for example, the *Cheltenham Flyer*, which ran the Great Western Railway's express service from Cheltenham to London, became the world's fastest train when it achieved an average speed of 81.6 miles per hour on the section of line between Swindon and Paddington. In 1941, Sir Frank Whittle (1907–96) assembled Britain's first jet engine in a Regent Street garage. However, there have been other examples where the town can rightly claim its first place in history.

> DID YOU KNOW?
> Mr J. W. Austin is said to have walked 224,800 miles around Cheltenham's streets, the equivalent of nine times round the world. Employed as a lamplighter for forty-five years from 1861, it is likely that Mr Austin's achievement has never been surpassed, at least in Cheltenham. By the middle of the nineteenth century the town was illuminated by more than 750 gas lamps.

Youngest Solo Aeronaut

In the early nineteenth century Cheltenham's status as a fashionable place led to it hosting many dramatic aeronautical events. On 6 September 1813, for example, James Sadler, the first Englishman to make a balloon ascent, planned to perform an exhibition flight from Cheltenham, either as a solo balloonist or with his youngest son, Windham, as co-pilot. A committee of 'twelve respectable inhabitants' was appointed to organise the event, and tickets were sold at 10s 6d apiece. However, windy conditions halted the preparations and led James to suggest postponing the ascent, weather permitting, to the following day. Despite calls to postpone it further to avoid clashing with the Hereford Music Meeting, James's proposal was accepted to avoid disappointing the large influx of visitors.

Sadler's balloon, made of white and crimson silk in the shape of a Windsor pear, was put on display at the Assembly Rooms (now the site of Lloyd's Bank on the High Street). At 10 a.m. on 7 September it was transferred to the railway yard on Gloucester Road to prepare for the launch. The wind was still causing problems, but by 4.20 p.m. everything was ready. However, when James stepped into the basket, his weight proved too great. Problems had arisen both from the quality of the silk used and the amount of gas able to be generated for inflation from sulphuric acid and iron filings. To mitigate this, Windham

BALLOON.

MR. SADLER intends to Ascend in his BALLOON from the Large Wharf, at Cheltenham, before the expiration of Three Weeks, if he meet with sufficient encouragement. He therefore solicits the favour of the attendance of the Visitors, and Inhabitants of the Town, and its Vicinity, TO-MORROW, (Friday,) at the ASSEMBLY-ROOMS, at Twelve o'Clock, to Elect a Committee.—Books will be immediately OPENED at the Rooms, and Public Spas, for Subscribers' names.

Advert for Sadler's balloon ascent.
(*Cheltenham Chronicle*, 5 August 1813)

Sadler replaced his father, stepping into the basket 'with all composure, fortitude, courage and indifference that his veteran father [possessed]', enabling the lighter-weight balloon to finally ascend at 5 p.m.

Initially remaining in sight for seven minutes, the balloon then became obscured in cloud for five minutes before reappearing at the eastern side of the town. Windham's father, with his eldest son on horseback, tried to follow the balloon in a carriage, but they soon lost sight of it. Nevertheless, ballooning history had been made. At the age of sixteen, it is claimed, Windham became the youngest ever solo aeronaut. However, the flight was not plain sailing. A heavy fall of snow hit against the balloon with such ferocity that he struggled to open the valve to reduce altitude. Later, descending low near Wychwood Forest, he ejected the ballast so that he could continue the journey. At 5.50 p.m., he landed safely at Chadlington, near Chipping Norton, where he was accosted by a man armed with a pitchfork, who cried out, 'Lord, Sir, where have you come from?' Staying overnight in Oxford, Windham returned to Cheltenham the following day where he was reunited with his family and 'chaired round the town'.

First Steam-powered Bus Service
Another remarkable first occurred on 21 February 1831 when Sir Charles Dance, a lieutenant-colonel of the Life Guards and pioneering supporter of steam road vehicles, launched the world's first steam-powered bus service, operating between Cheltenham and Gloucester. It used three drags, steam-powered vehicles designed by the inventor Sir Goldsworthy Gurney (1793–1875) to each pull a carriage carrying from twelve to thirty

passengers. Originally intended as a pilot scheme for a Birmingham to Bristol service, the Cheltenham to Gloucester service ran successfully for four months four times a day until 22 June. It started at the Commissioners' Yard, Cheltenham (once situated in the angle of Gloucester Road and Tewkesbury Road, on land now part of Tesco car park), at 10 and 2 o'clock and returned from the Spread Eagle Inn, Gloucester at 12 noon and 4. Fares ranged from 2s 6d for seats inside the carriage to 1s 6d on the outside. Although the 9-mile journey was usually completed in less than an hour, it involved high maintenance costs to ensure the coaches were in good working order. If one of the tubes of the boiler burst, for example, an engineer would be required at a salary of £1 per day. Added to this were the concerns from the turnpike trustees and wealthy horse-coach proprietors whose interests felt threatened by the substitution of steam for horse power. This eventually led to the establishment of high tolls on steam carriages: £2 for a steam carriage compared with only 2s for a four-horse stagecoach. The service ended abruptly in June when the local turnpike trustees and horse-coach proprietors arranged for a section of the road near Cheltenham to be covered with a 1-foot-deep layer of crushed granite.

Remarkably, despite breaking one of the cranks in the rear axle, the drag and carriage succeeded in breaking its way through the rough gravel, completing the journey to Cheltenham in eighty minutes. However, given the hostile opposition to the scheme, Dance suspended his operations, while Gurney turned his attention to other directions, including inventing a new type of warm-air stove and introducing new lighting and ventilation to the Houses of Parliament. Although the men's pioneering efforts were halted by Luddite opposition, their achievements were impressive. During the four-month

1831 'One-Horse' Gurney. (*The Engineer's and Mechanic's Encyclopædia*, 1836)

period the Gurney carriages transported nearly 3,000 passengers and travelled 3,564 miles in 315 journeys. On average the journey took fifty-five minutes, and frequently forty-five, sometimes carrying as many as thirty-six passengers, and with no occurrences of injuries, accidents or breakdown of the engines.

DID YOU KNOW?
The term 'Beatlemania' was first used after the Beatles performed in Cheltenham. Following the Fab Four's opening concert of their UK tour on 1 November 1963 at the Odeon Cinema on Winchcombe Street, a *Daily Mail* article appeared the following day saying that 'Beatlemania' had gripped the country, adding 'even in sedate Cheltenham'. This is widely believed to be the first documented use of the term.

First Parachute Descent

In September 1838, John Hampton (1799–1881), who worked in the navy before turning professional aeronaut, announced that he would ascend with his balloon from Montpellier Gardens on 3 October. Significantly, he also planned 'to make his first descent in his improved safety parachute from his magnificent Balloon, "The Albion," at an altitude of at least 5000 feet, distinctly visible to the spectators as the state of the atmosphere will admit; it being Mr. Hampton's determination to perform this Novel and Enterprizing Feat within a convenient and practicable distance from the Gardens.'

A week before the event, Hampton exhibited his parachute at the Rotunda. It was umbrella-shaped, 15 feet in diameter and made of canvas over a framework of whale-bone ribs and bamboo stretchers. Weighing around 200 lbs, including 56 lbs of ballast, the parachute was attached by a copper tube to a small wicker basket. Hampton's plans for the descent were supported by assurances that the parachute 'has been examined by various Scientific Men and Professors of Aerostatics in the Metropolis, who have satisfactorily affirmed that its attainments are certain and Divested of Danger...'

To guarantee full safety, however, the local magistrates insisted that Hampton could only use the town's gas supply if he agreed to tether his balloon. Despite this, once his balloon reached 300 feet, Hampton severed the restraining ropes. At around 9,000 feet, he then cut loose his parachute, applying his knife to 'the only cord which held me between Heaven and the vast abyss beneath me'. After the separation his gas-filled balloon ascended a few hundred feet further and exploded 'with the violence of a thunderbolt' as spectators looked on in horror. Nevertheless, in accordance with his original plan, while the balloon immediately collapsed and fell back to the ground, Hampton's parachute went into a gradual descent. Approximately thirteen minutes later, Hampton landed safely in a field full of sheep at Badgeworth.

At that moment John Hampton became the first Englishman to descend by parachute. Today, a Civic Society blue plaque, unveiled on Montpellier bandstand in

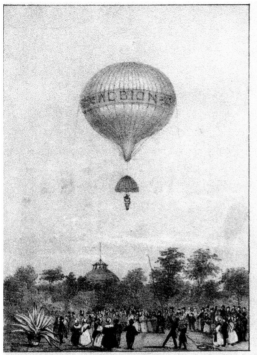

A S C E N T A N D D E S C E N T

M.ʳ Hamptons *Balloon and Parachute,* from the *Montpellier Gardens, Cheltenham,* October 3.ᵈ 1838.

Published by H Davies, Cheltenham.

Hampton's parachute ascent and descent, 3 October 1838.

2008, commemorates his achievement. Following his escapade, Hampton wrote to the *Cheltenham Chronicle* asking for forgiveness for not adhering to the direction of the local magistrates and superintendent of the gas works. The editor responded, saying that 'a benevolent public will forgive Mr. Hampton for the trivial offence of which he was guilty, in parting so unexpectedly, the only tie which bound him to the nether world, as a *ruse de guerre,* perfectly justifiable under the circumstance.'

DID YOU KNOW?
On Sunday 10 August 2014, 1,043 people danced a variation of jive simultaneously on the Promenade. This successfully set the official Guinness World Records title for 'the most people jiving simultaneously in a single venue', and was achieved for the minimum five minutes period required despite the wind and rain of Hurricane Bertha! In the run-up to the record attempt six free jive classes were held at Cheltenham Town Hall to teach the basics, or help dancers brush up on their technique.

Acknowledgements

I am most grateful to Alan Murphy at Amberley for commissioning the book. Also, a number of museums, libraries and archive services have provided me with excellent support. My thanks in particular go to all the staff at Cheltenham Local Studies Centre. I am also grateful to Dr Steve Blake, Dr James Hodsdon, Neela Mann, Eric Miller and Jill Waller for commenting on the draft, as well as to Anne Strathie for detailed research relating to Mrs A'Court's memorial. Other help and assistance have been gratefully received from Rachel Roberts, Simon Ford, Jim Maitland, David Hanks, Ken Brightwell, Elise Hoadley, Karen Soo, Florence Nyasamo-Thomas, Rob Grey, Jenny Lockwood, Claire Spanner, Rachel Lang and Grace Pritchard Woods. I should also like to thank the following for granting me copyright permission to use various images: Cheltenham Local Studies Centre for the historic photographs, prints and drawings on pp. 5, 26, 28 (right), 32, 41, 51, 54–6, 60, 66, 71–3, 75, 81 (top), 86, 91; GCHQ Press Office for the Crown Copyright images on p. 18; The Cheltenham Trust and Cheltenham Borough Council for the images on p. 47 and p. 94; Sue Rowbotham for the image on p. 77; Neela Mann for the images on pp. 18 (left), and 61–2; Lloyd's Bank for the image on p. 30; Andrea Watt (Pegasus Life) for the image on p. 35 (bottom); Rachael Merrison (on behalf of Cheltenham College) for the images on pp. 48, and 83 (right); Peter Gill for the image on p. 31; Cheltenham Ladies' College for the image on p. 84; Karen Soo for the images on pp. 52–3; Vic Cole for the image on p. 87; Philip Dixon for the image on p. 17 (top); Dean Close School for the image on p. 50 (bottom); Darren Morris (on behalf of the East Glos. Club) for the image on p. 45 (top). The image on p. 57 (top) was taken from an original copy of the poster held in Cheltenham College Archives. The images on pp. 37 and 70 (bottom) are reproduced from the collections of the Library of Congress. The image on p. 57 (bottom) is © Imperial War Museum (Art.IWM ARTLD 2758). Jabez Hughes's photograph on p. 83 (left), 'Prince Alamayou on Ryde, Isle of Wight 1868' is reproduced courtesy Autograph ABP. The copyright of all other images belongs to the author. Finally, my heartfelt thanks go to my family, Meg, Rachel, and Catrin, for their patience, support and encouragement.

About the Author

David Elder lives in Gloucestershire. He is the author of several books on Cheltenham, Gloucester, Tewkesbury and the Cotswolds. He also co-authored *Cheltenham in Antarctica*, a biography about Edward Wilson, the Antarctic explorer. You can find out more about David's writing from his website, davidelder.net.